Russia's Four Seasons

Elisabeth Ingles

*Landscapes and
Images of
Mother Russia*

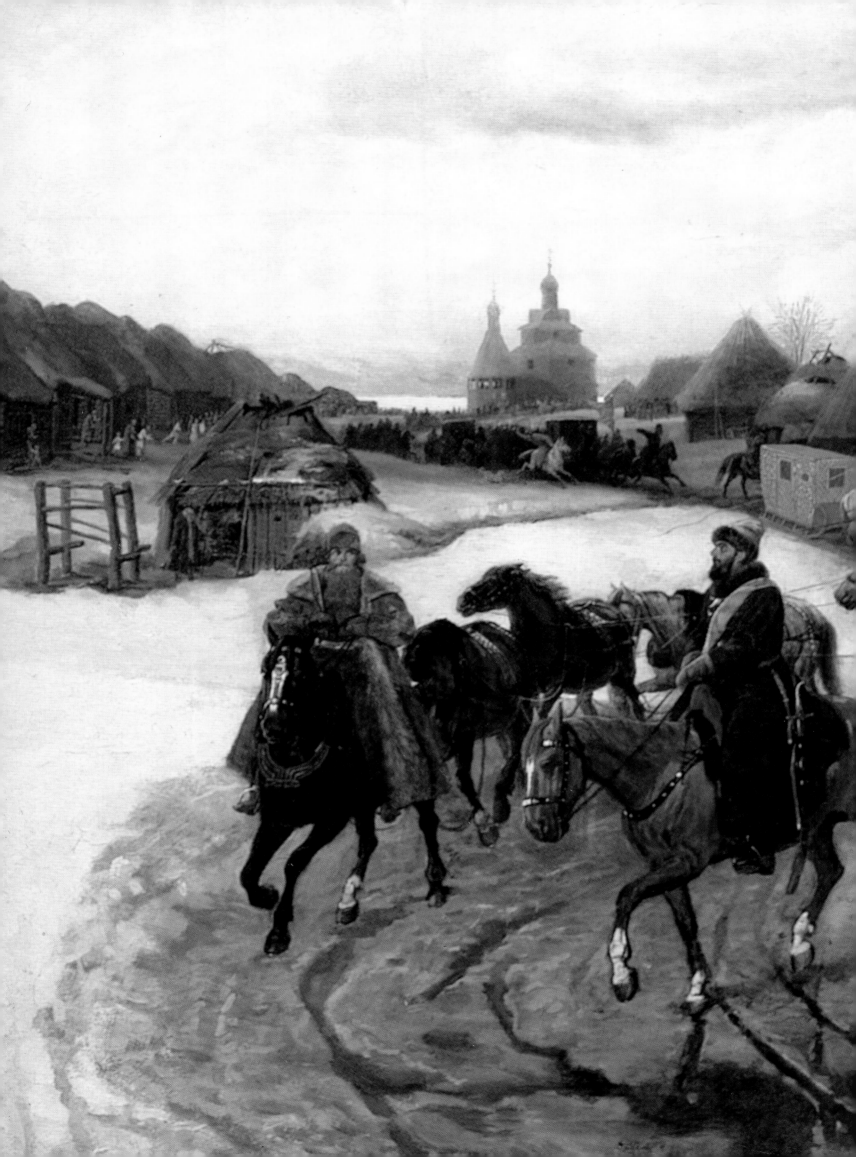

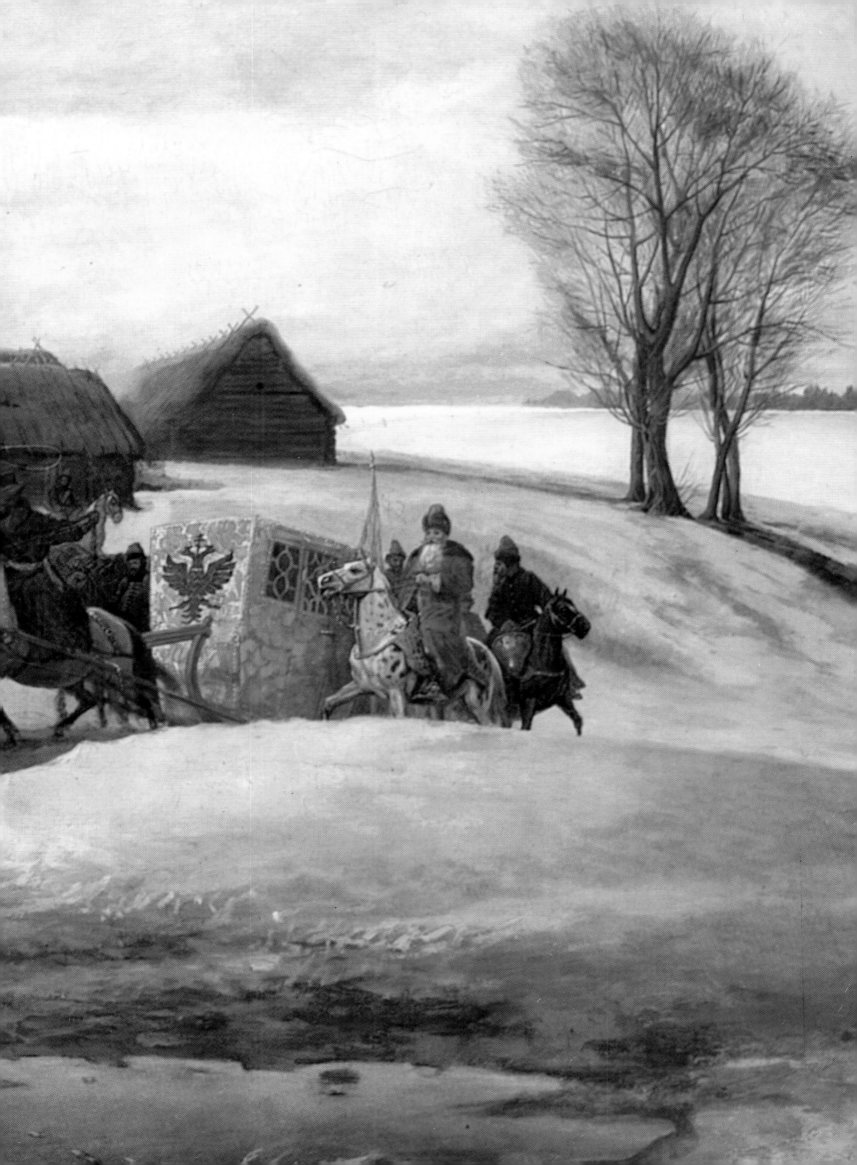

Publishing Director: Jean Paul Manzo

Designed and typeset by: Russell Stretten Consultancy

Editor's Assistant: Nathalie Meyer

Publishing Associate: Cornelia Sontag

Text by: Elisabeth Ingles

Preceeding pages:
24- Viacheslav Schwarz

*The Tsarina's Spring
Pilgrimage in the Reign of
Alexei Mikhaïlovich, 1868*

RUSSIA'S FOUR SEASONS

Landscapes and Images of Mother Russia

Elisabeth Ingles

PARKSTONE PRESS

Contents

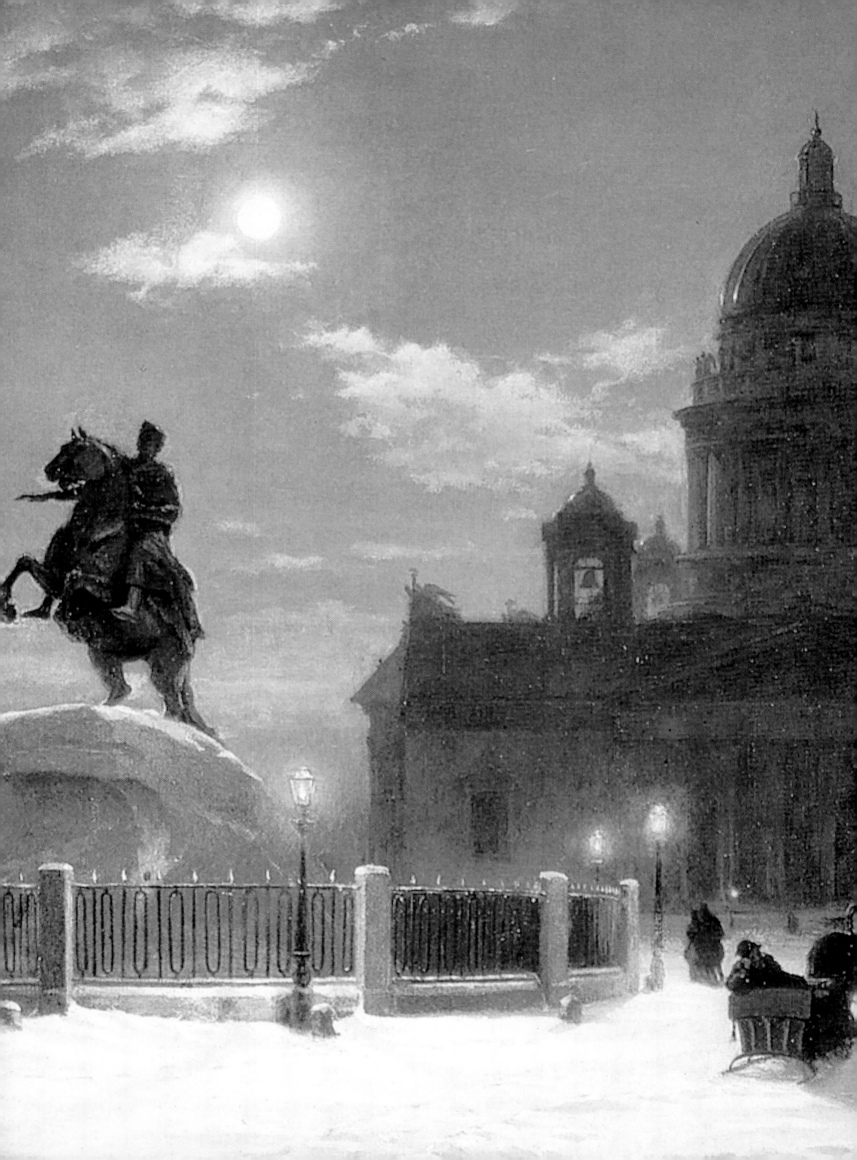

THE LAND AND THE SOUL

The world swelters in the sun,

The wooded hollow storms into frenzied life,

Work seethes in the hands of the spring,

That strapping dairymaid.

The snow is wasting away

In little branches like weak blue veins,

But the cowshed smokes with life,

The teeth of the pitchforks bristle with health.

These nights, these days and nights:

Rain drumming on the window at noon,

The thin dripping of icicles on the roof,

Chatter of sleepless streams.

Everything is thrown open, stables and cowshed.

Pigeons are pecking oats in the snow.

The culprit and the life-giver

Is the dung with its smell of fresh air.

Boris Pasternak, *March*

In Pasternak's vivid poem of spring, the very earth breathes an almost physical expression of the Russian spirit. The land of Russia has always been closely bound up with the soul of its people. It nourishes them, it is loved by them with the kind of deep and abiding love they feel for a mother. Indeed, 'Mother Russia' is a phrase gravid with meaning, not far removed from 'Mother Nature'.

Our journey through the romantic landscapes of this vast country has as its aim the discovery of the Russian soul, which for all its complexities is a tapestry woven from a few powerful strands. The love of the land is reinforced by a firm religious faith; another part of the weft is devotion to the family – not simply those who are

162- Vasily Surikov

Monument to Peter the Great on Senate Square in St. Petersburg, 1870
Oil on canvas. 52 x 71 cm
Russian Museum, St. Petersburg

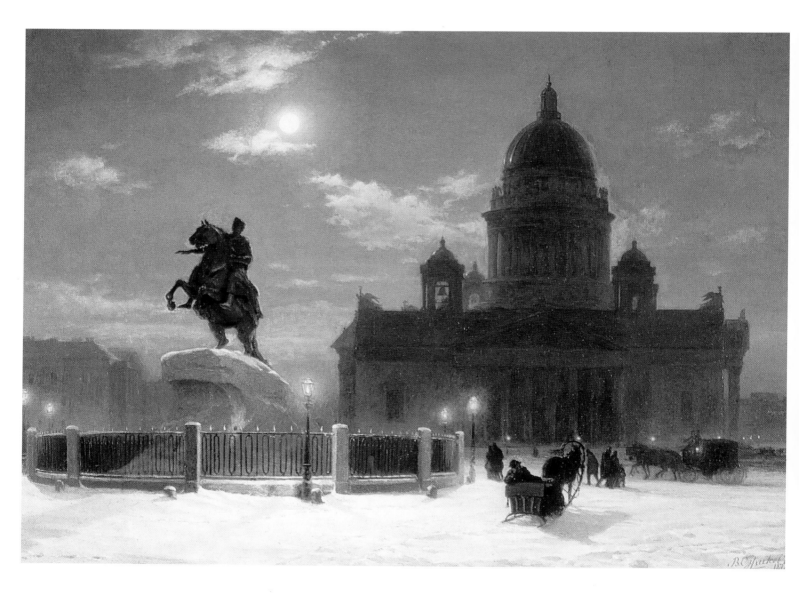

10

living but those who have gone before, and those who are
yet to come. All these elements combine to form an
unquenchable spiritual resource, which has sustained
millions of Russians over the centuries.

In these pages we will explore the landscapes and
cityscapes of Russia in all their seasonal variations, from
spring to winter and back to spring. Before doing so,
however, we should attempt to explain what is behind our
definition of the Russian soul. First of all, we need to look
at the events of centuries that have shaped the land and its
people. Following that, a brief outline of the history of
landscape painting is necessary as an introduction to our
journey through the seasons.

The vastness of Russia is as hard to encompass in the
mind of the outsider as the possession of a limitless
fortune would be for a beggar. Yet, somehow, in every
Russian, whether from the glacially beautiful St Petersburg
[162] or from the warm Mediterranean climate of the Black
Sea coast [156], love for the native land is a binding thread.
And this love, which is the essence of the Russian soul,
has survived all the vagaries that history has thrown at it.

'Russia', for our purpose, coincides roughly with the

156- Sebastopol

11

territory of the recently constituted Russian Federation, together with Belorussia and the Ukraine. There is no doubting the patriotic feeling among the citizens of the other former Soviet republics, but the ethnic origins of the population east and south of the Urals are not Slav, and the soul of a Kirghiz or Uzbek, whatever poetry he may find in his surroundings, does not quiver to the same stimulus as that of a native of the Russian heartland.

What exactly is this heartland? Ancient Rus, its origins lost in the mists of time, encompassed two vast areas. This pagan land was vividly evoked by the viscerally

196- Nikolai Roerich

Kissing the Earth
Set design for Act 1 of Igor Stravinsky's ballet "Le Sacre du Printemps", 1912
Tempera on cardboard. 62 x 94 cm
Russian Museum, St. Petersburg

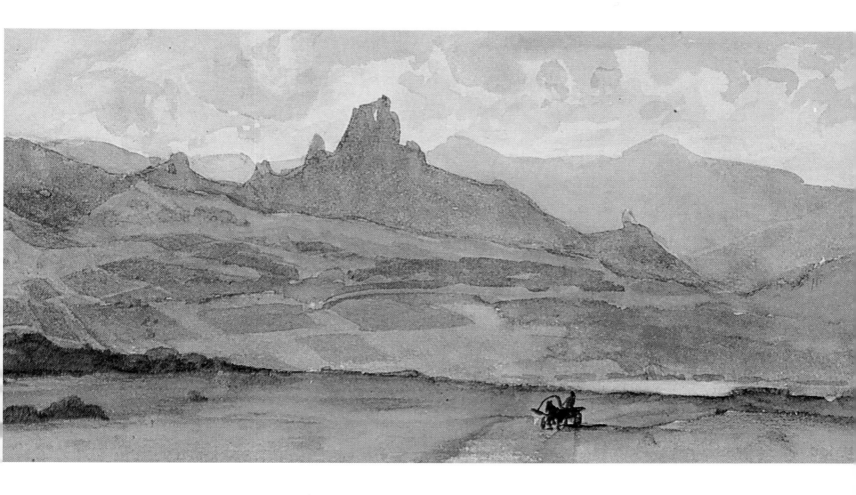

exciting, crashing rhythms of Igor Stravinsky's "The Rite of Spring", and by Nikolai Roerich in his exciting set designs of 1912 for the ballet [196]. The northern region was covered in the primeval forest, dark, mysterious and threatening, that stretched from Western Europe to Siberia in prehistoric times. To the south of this, the steppe extended in a vast sweep eastwards, bleak and inhospitable, and was home to a myriad nomadic tribes. The Siberian-born Vasily Surikov's romantic 1873 watercolour of The Minusinsk Steppe gives an idea of the region's arresting landscape [164]. These two contrasting regions were first ruled from Kiev, and were christianized in the 10th century. From the 13th century onwards Moscow grew into her own as the dominant city, and her princes, often embattled against the terrifying Tatar hordes that invaded from Mongolia, gradually extended their influence over the whole of what we now think of as Russia.

164- Vasily Surikov

The Minusinsk Steppe, 1873
Watercolor on paper.
136 x 31.8 cm
Tretyakov Gallery, Moscow

13

201- Isaac Levitan

Above Eternel Peace, 1894
Oil on canvas. 150 x 206 cm
Tretyakov Gallery, Moscow

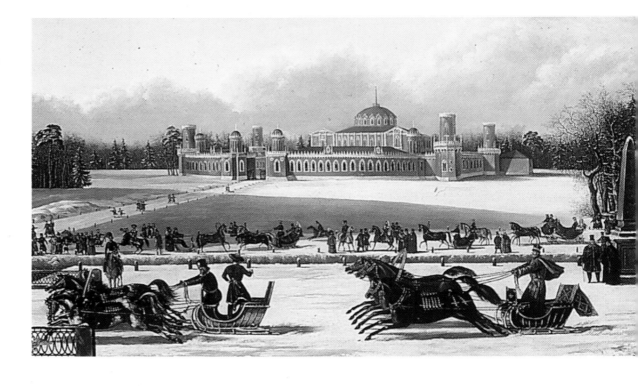

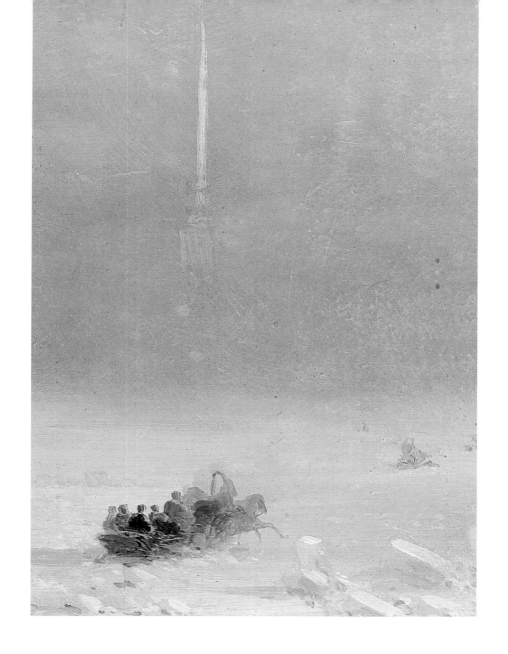

For more than a thousand years the various populations of this enormous territory, not all of them Slav in origin whether indigenous or invaders, have cohered into a unique people, the Russians, with their own indefinable quality which is expressed in the word 'soul'. The Russian soul is bound up, both spiritually and in a strong sense physically, with the landscape. A Russian uprooted from his country feels a great yearning for these vast spaces, expressed marvellously in Levitan's Above Eternal Peace [201] – the lakes, rivers, forests and steppes which have so far resisted domination by technology and industry by reason of sheer size. And from the time that Moscow came to prominence as the capital, a homely city in which little alleys lined with brightly painted wooden

15

houses decorated with 'gingerbread' fretwork were interspersed among beautiful stone churches and palaces, the Russian soul responded to cityscapes too. An anonymous painting of the 1840s, Sleigh Races in the Petrovsky Park [75], shows a delightful scene on the edge of the city, with trees and the splendid palace in the background. The primeval forest came right up to the walls of the city: even today there is a Borovaya Square, one of the oldest in Moscow, and a Borovitsky Gate in the Kremlin (the word bor means forest). The first Kremlin fortress, and indeed the early city, were constructed from the pine that was harvested from the dense woods all around.

As the power of Moscow grew and was tested against fearful dangers – invasions by the fierce Tatars from the east, incursions from well trained and equipped bands of Swedish and German knights and mercenaries from the west – these tribulations engendered a fierce patriotism. The focus of this patriotic fervour in the 13th century was Prince Alexander Nevsky, a heroic figure who twice repulsed the threat from the west and consolidated the power of the emergent nation. His exploits are commemorated in the 1938 film by Eisenstein, and by the music Prokofiev wrote for it, with its stirring climax of the Battle on the Ice against the Teutonic knights on Lake Chudskoye: 'No foe shall march across Russian land, neither shall foreign troops raid her!' A ghost of this tremendous feat is perhaps glimpsed in the atmospheric St Petersburg. Crossing the Neva [111] by Ivan Aïvazovski (1817–1900), in which the wintry weather is the chief protagonist, and the lumps and blocks of ice form a fearful obstacle for the horses struggling valiantly to pull the sleigh across the frozen river.

From early times Moscow assumed an almost mystic status as the power-base of the Russian Orthodox Church, and this gave the city tremendous authority over the whole of the Russian lands, enabling them to be

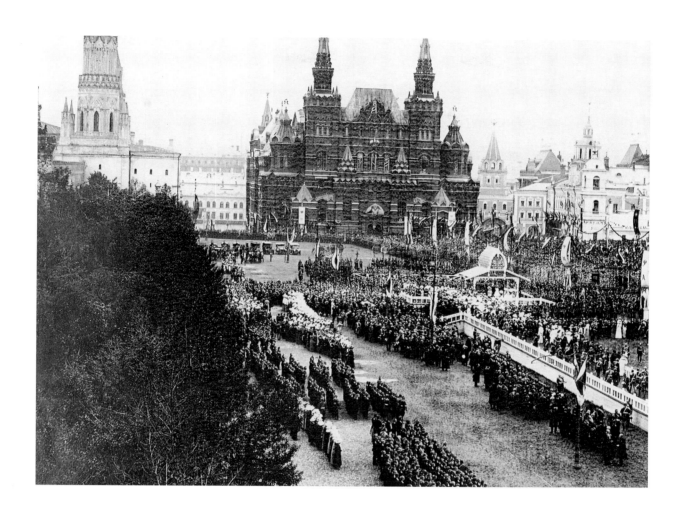

assimilated relatively easily into the central state. Religious fervour – still strongly acknowledged in 1912, when this photograph of public prayer in Red Square [158] was taken – formed yet another aspect of the Russian soul, mingling with and reinforcing its already strong patriotic bent. By the 15th century Moscow was truly the centre, in every sense – secular, religious, economic and cultural – of a newly unified land, and its grand prince became all-powerful. It was at this point that he became designated 'Tsar' (from the Latin Caesar, emperor): Ivan III was the first to call himself thus, and with reason, for by virtue of his marriage he was also the heir of Byzantium. By the 16th century Moscow was a town of 100,000 inhabitants, bigger by far than almost any other contemporary city in the Western world. The Romanov dynasty that came to the throne in 1613, in the person of Tsar Mikhail I, was to last until the tragic events of 1917. At the coronation

158- Public Prayer in Red Square

of Peter the Great, those who swore the oath of allegiance had to do so not only to the Tsar, but to the state as well. This had the effect of strengthening the ordinary Russian's notion of loyalty, fostering that sense of nationhood which we have already come to realize is so important an element in the Russian soul.

Townscapes, as we have already observed, appealed to the Russian love of homeland as much as landscapes, and Moscow in the 18th and 19th centuries had some magnificent views to record [120]. Many fine buildings in and around the city still exist, particularly religious ones, as the photographs on these pages attest: the Trinity—St

120- Isaac Levitan

The Quiet Monastery, 1890
Oil on canvas.
87.5 x 108 cm
Tretyakov Gallery, Moscow

Sergius Monastery [77], built over a lengthy period between the 15th and the 18th century, and the Novodevichy Convent [76], beautiful under its covering of snow. An interesting group of buildings to the south-west of the city, the latter was begun in the 16th century by Grand Prince Vasily III to mark the victory over Poland at Smolensk. It long provided a focus for the elaborate and beautiful religious rites through which the ordinary

77- Moscow

Serguiev-Possad

*The Trinity-St. Sergius Monastery
An architectural ensemble of
the 15th-18th centuries*

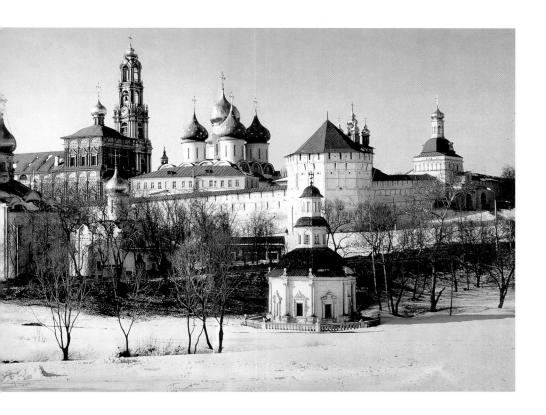

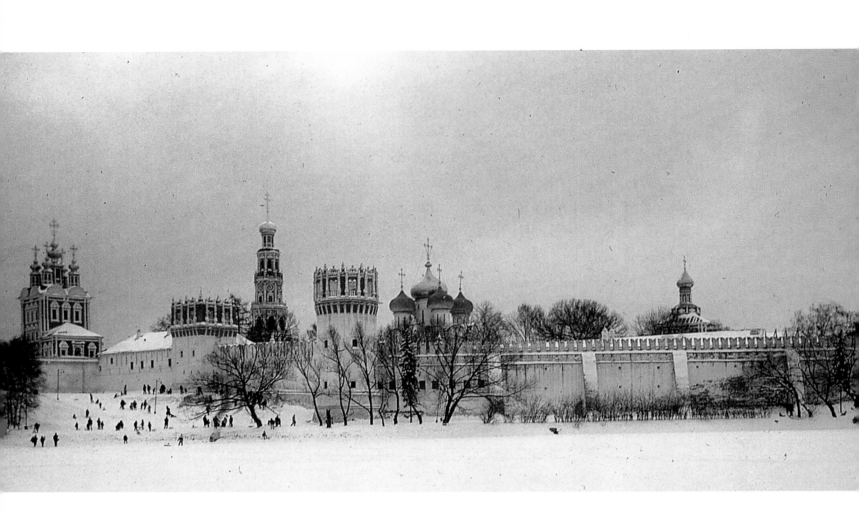

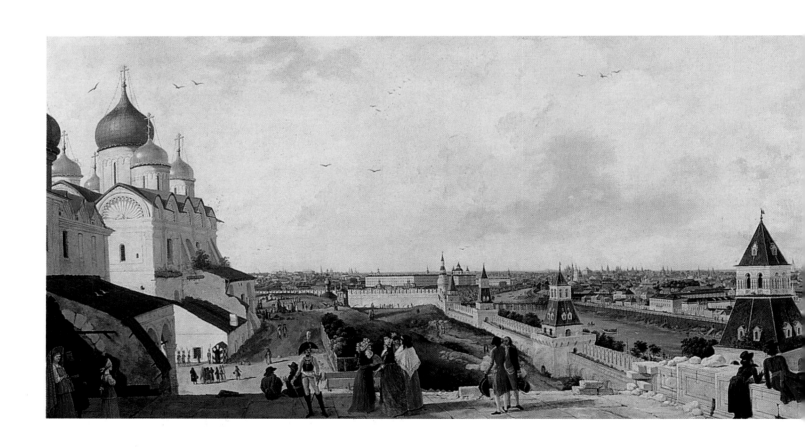

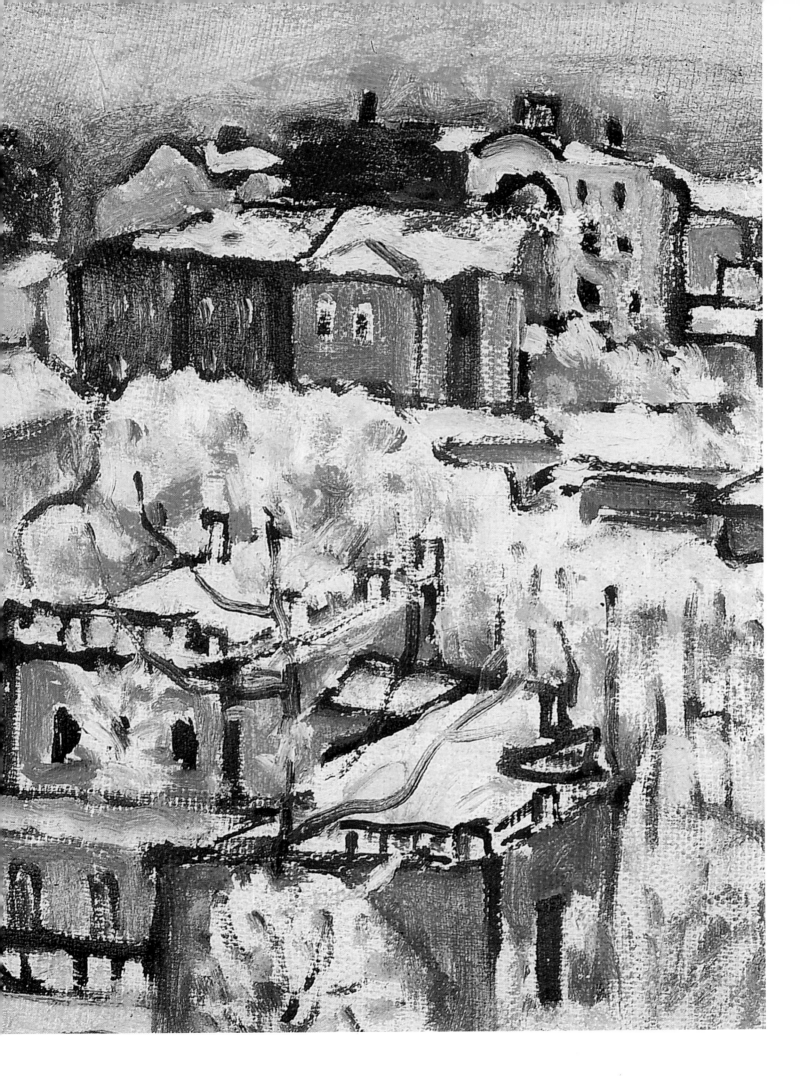

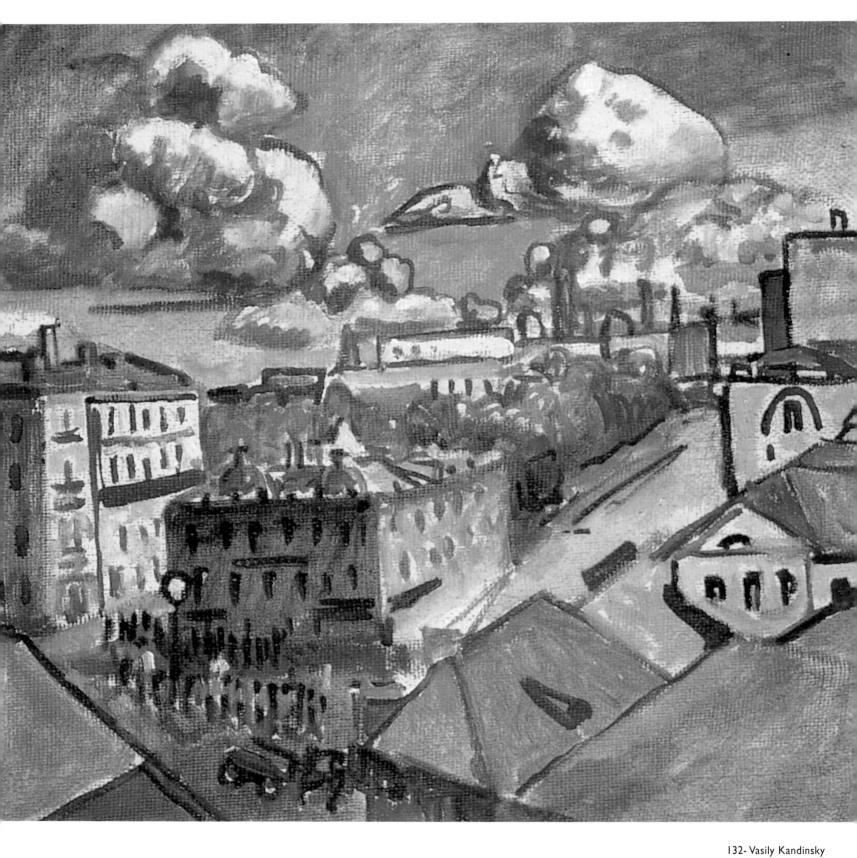

132- Vasily Kandinsky

Moscow, Zubovsky Square,
ca. 1916
Oil on cardboard.
34.4 x 37.7 cm
Tretyakov Gallery, Moscow

Russian could express his love of God. One of the earliest topographical views is a charming painting by the visiting Frenchman Gérard de la Barthe, View of Moscow from the Balconies of the Kremlin [74], executed in the 1790s, before the war with Napoleon and the devastation it brought in its wake. Two townscapes by Vasily Kandinsky [131] [132] show the city in its winter and summer garb. These paintings can be described as representational, in contrast to Kandinsky's more familiar abstract manner, but they are nevertheless carefully built up of non-figurative blocks of colour, in line with his experiments in Murnau. They were done on one of his visits home from Germany – a

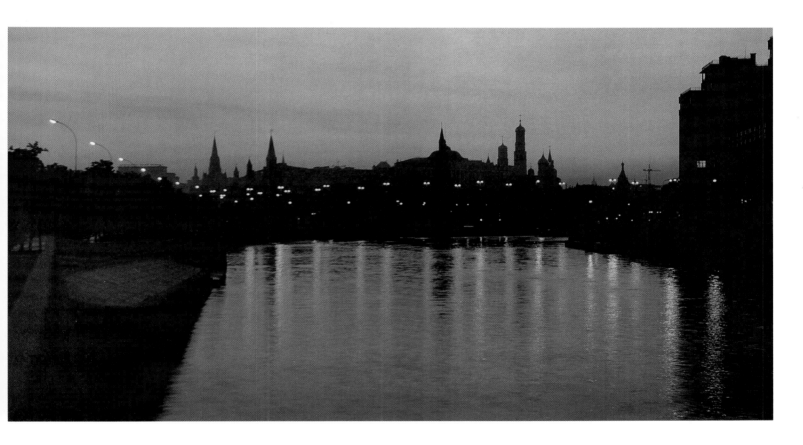

true Russian, in spite of his lengthy stays abroad, Kandinsky needed to return from time to time to nourish and refresh his spiritual strength.

The Kremlin has always been the focal point of Moscow [155]. Astonishingly huge and rambling, the citadel's cathedrals, palaces and towers embrace all manner

*155- Moscow,
Kremlin by Night*

23

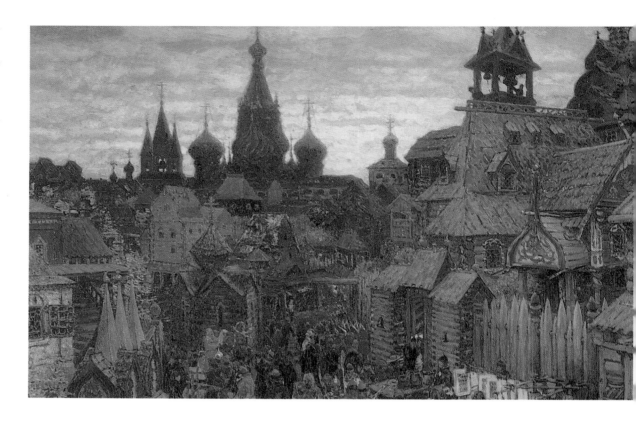

118- Apollinari Vasnetsov

*The old Moscow,
a street in Kitai-Gorod
in the 17th century, 1900
Oil on canvas. 125 x 178 cm
Russian Museum,
St. Petersburg*

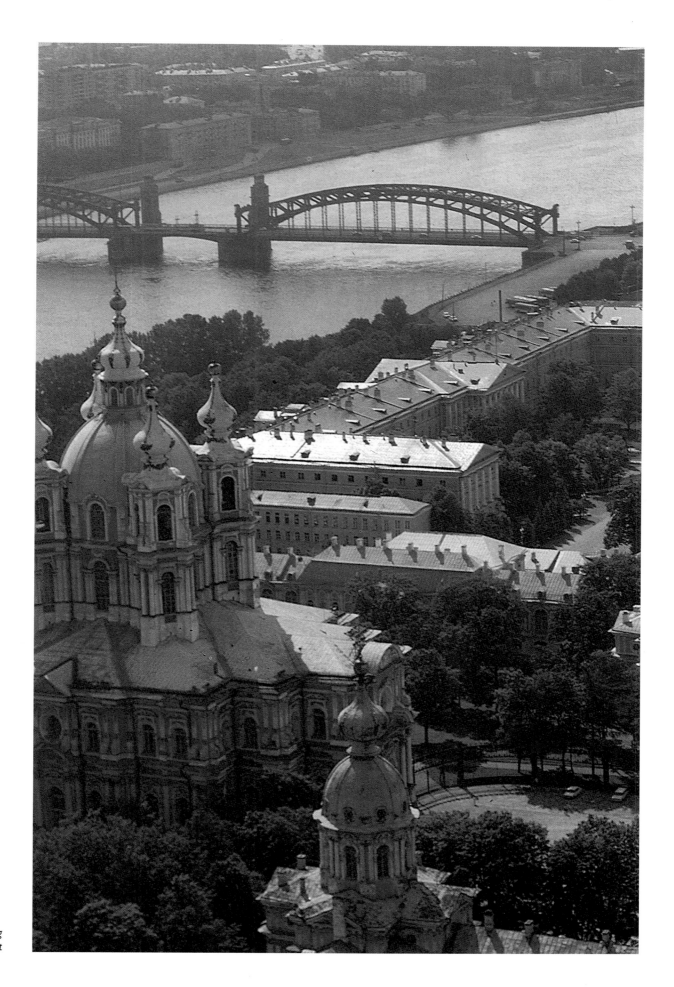

To left:
163- Vasily Surikov

View of the Kremlin, 1913
Oil on canvas. 29 x 48 cm
Tretyakov Gallery, Moscow

5- Saint Petersburg
View of the Smolny Convent

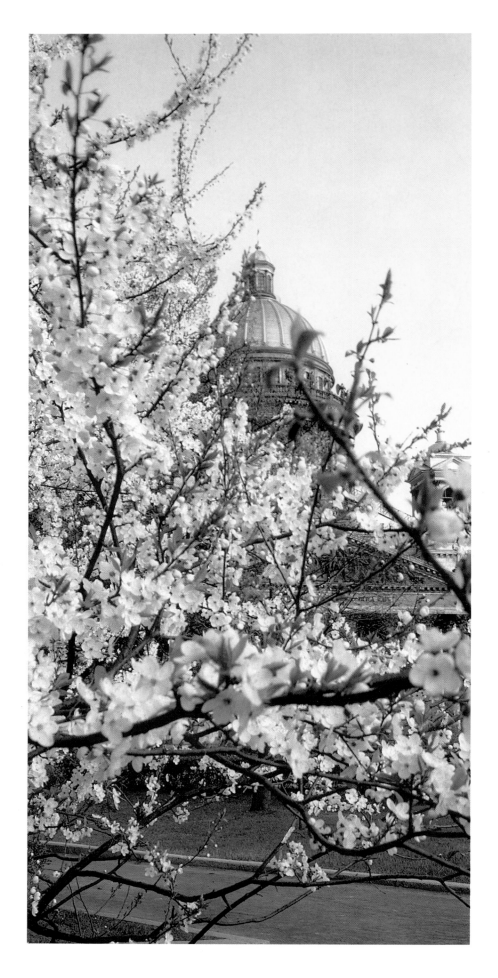

1- Saint Petersburg
St. Isaac's Cathedral

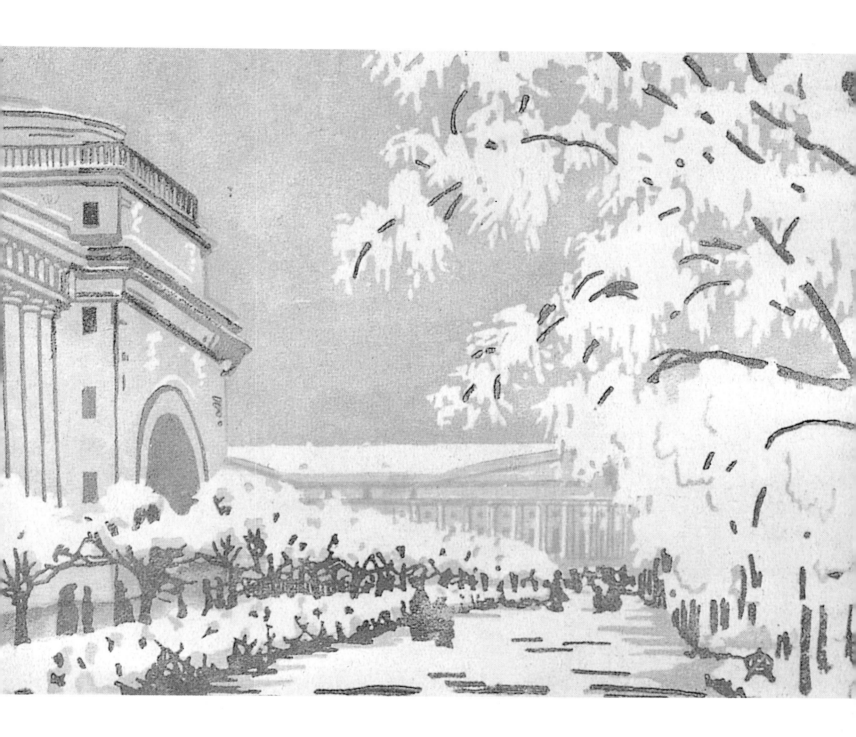

198- Anna Ostroumova-
Lebedeva

Admiralty Clad in Snow, 1901
Colored woodcut

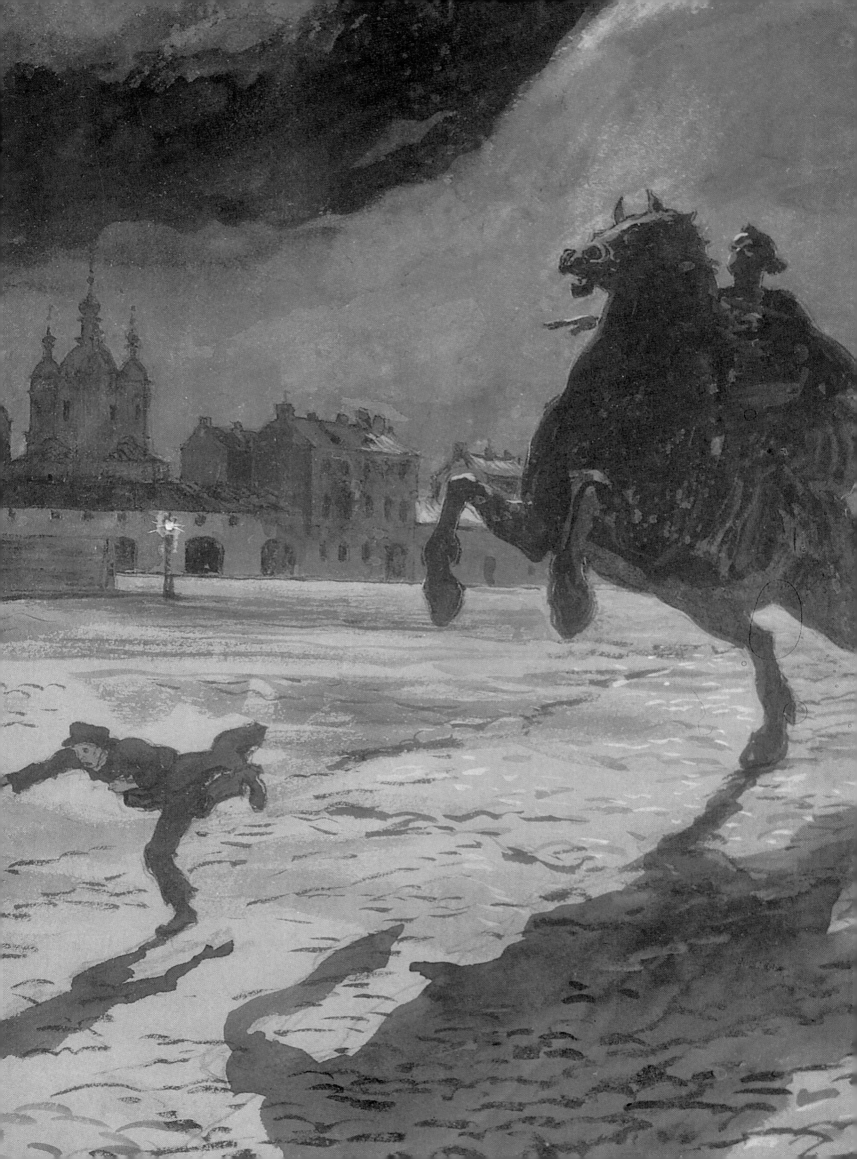

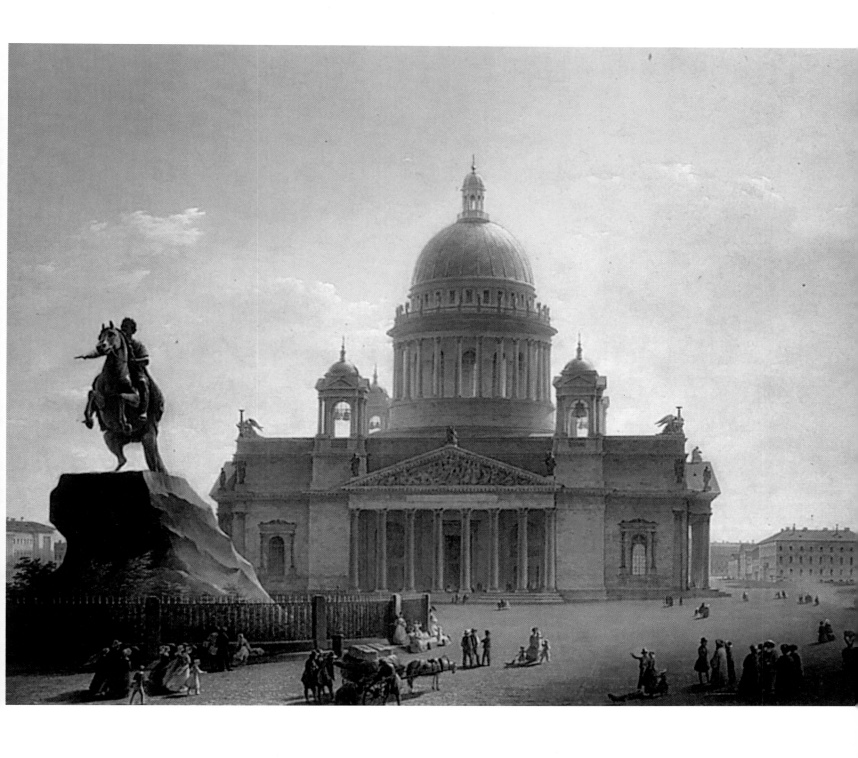

of architectural styles and periods, and their diversity has posed a challenge to many artists. Apollinary Vasnetsov (1856–1933) painted a lively market scene with the citadel in the background, bathed in a warm golden-brown glow [118]. The fantastical shapes of the roofs in the foreground blend happily with the famous domes behind, thrusting into the sunset sky. Vasily Surikov's winter view shows a very different aspect, although the painter's

2- Saint Petersburg
Monument to Nicholas I,
1856-1859
Sculptor Piotr Klodt,
on St. Isaac's Square

viewpoint is once again a high one. Here the day is gloomy and the buildings seem to huddle together for warmth under a thick blanket of snow [163].

Napoleon's invasion of Russia and his retreat from Moscow in 1812 was above all else the event that consolidated patriotic fervour in the hearts and minds of the people. The defenders resolved to do everything in their power to defeat the invader, and much of Moscow was burnt to the ground; crops were destroyed, wells poisoned and animals killed. As Tolstoy in 'War and Peace' put it: 'The enemy is advancing to destroy Russia, to desecrate the tombs of our fathers, to carry off our wives and children. We will all arise, every one of us will go, for our father the Tsar! We are Russians and will not grudge our blood in defence of our faith, the throne, and the Fatherland! We must cease raving if we are sons of our Fatherland! We will show Europe how Russia rises to the defence of Russia!' After so tremendous a sacrifice, Moscow came to embody the spirit of independence of the Russian nation. This resolve was to be tested again, just as severely, in World War II, when 20 million Russians died. This time it was St Petersburg that was under siege, for 900 days. The people were reduced to eating rats, the dead lay unburied, but the indomitable Russian spirit was never broken.

In contrast to Moscow, St Petersburg was built all-of-a-piece, founded only in 1703 by Peter the Great (1672–1725). It was a purpose-built capital, the fruit of Peter's desire to bring his nation into greater contact with the rest of Europe and to be a showcase for the 'new' country that he was fashioning through his reforms. He did not manage these without resistance: the traditional qualities of his people were somewhat at odds with this new, very European city. What Pushkin calls its 'austere, elegant appearance' was created by employing Italian architects and designers who created a Baroque and neoclassical city of the highest refinement. The Smolny

Convent and Cathedral [5], designed by Francesco Bartolomeo Rastrelli in the mid-18th century, exemplifies Russian Baroque at its finest and most ornate, giving glorious expression to the religiosity of the people. Later buildings were designed to harmonize with the original concept of the city. The skyline is dominated by the cathedral of Sts Peter and Paul, the cathedral of St Isaac – seen here in a glory of spring blossom [1] – and the Admiralty [198], depicted under a leaden winter sky in a woodcut by Anna Ostroumova-Lebedeva (1871–1955), who specialized in such townscapes.

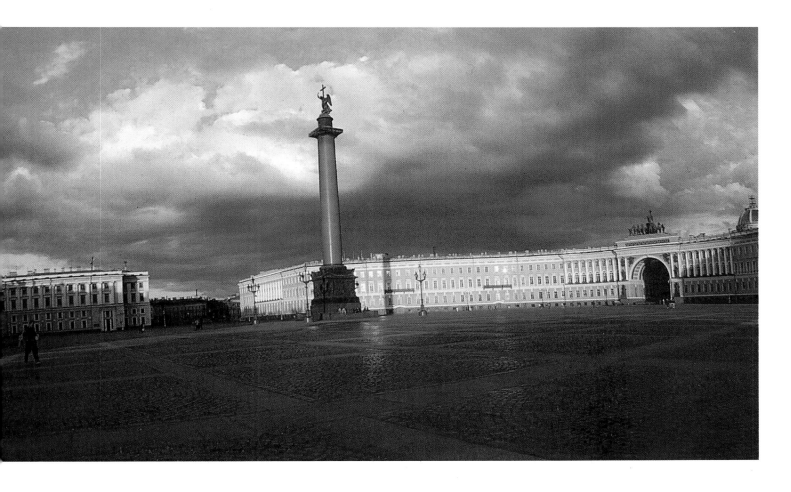

Pushkin's tale 'The Bronze Horseman', memorably depicted by Alexander Benois [195], was inspired by the equestrian statue of the founding Tsar, the very spirit of the city, that rears up towards the Neva. Pushkin describes it as a monument to the emperor who 'made Russia rear up'. As Nikolai Antsiferov put it: 'What a great sweeping

3- Saint Petersburg
The Alexander Column and
the General Staff building,
1819-1829
Architect Carlo Rossi, on
Palace Square

33

gesture, evoking the alarmed question: what's to come, what's ahead? Victory or failure and death?' Maxim Vorobyev included it in a fine view of St Isaac's Cathedral [110] (1844), the monumental building looming benignly over the people hurrying through the sunlit square. The same scene in winter was painted by Surikov in the 1870s (see page [1] [162]). Another equestrian sculpture, that of Nicholas I [2], enhances the streetscape with its majesty even on a dull winter's day; while the Alexander Column on Palace Square [3], here photographed beneath a dramatically lowering spring sky, is a perfect foil to the grandeur of the early 19th-century General Staff building designed by Carlo Rossi.

The Europeanization of Russia was continued, later in the 18th century, by the German-born Empress Catherine II, the Great (r. 1762–96). Catherine took to her role as a Russian ruler with gusto, convinced that she was to be a leading figure in her adopted country's history. 'I wish and want only good for the country to which God has brought me. Its glory will glorify me as well', she stated. Her love of luxury and beauty is well attested, and she added not a little to the stock of magnificent buildings in and around St. Petersburg. Her favourite architects were the Scotsman Charles Cameron, who decorated her apartments in the splendid complex of Tsarskoye Selo, and the Italians Antonio Rinaldi and Giacomo Quarenghi. In the 1760s Rinaldi created the Gatchina palace and park for Catherine's lover Count Grigory Orlov, to whom she had given the estate. The delightful humpbacked bridge in the photograph [6] connects two of the lake's islands. A monument to the Empress, a larger-than-life character in every way [4], presides over the snowy gardens of the Alexandrinsky Theatre, an early 19th-century gem in the Nevsky Prospekt, St Petersburg's immensely long principal thoroughfare.

Beautiful and grand as it is, the city is an astonishing

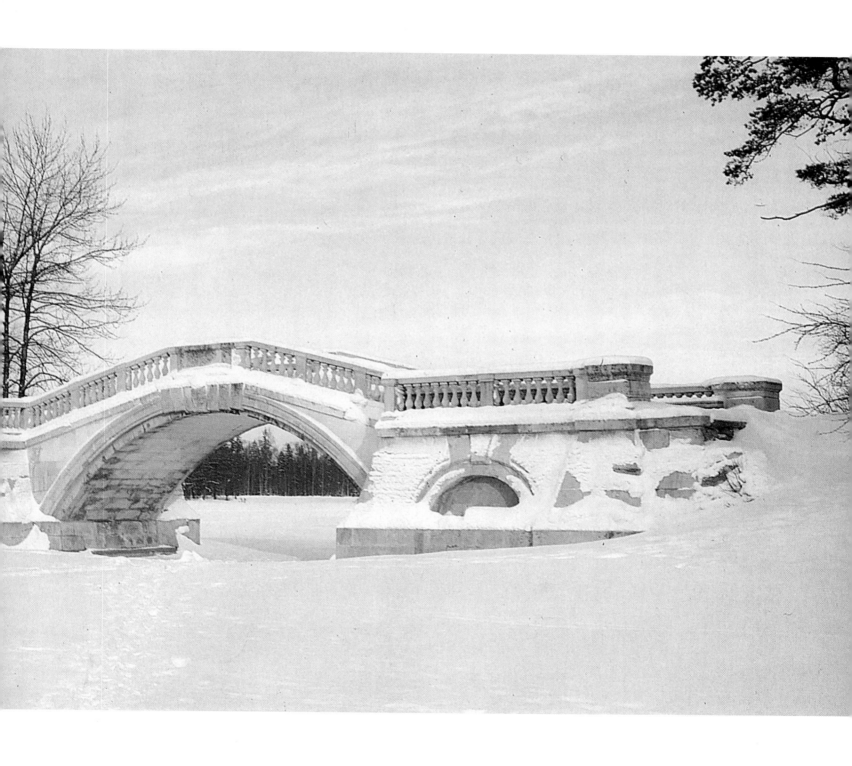

6- Saint Petersburg
Humpbacked Bridge

achievement of architectural harmony, with its richly coloured façades lighting up an all too often cheerless climate; but it lacks real warmth – its splendour does not accommodate a welcoming heart. Perhaps this lack has stimulated the fervour and passion that we perceive in the great writers whose careers flourished here: Pushkin, Gogol, Dostoyevsky, Blok. It was surely here that Dostoyevsky had in mind when he wrote that the Russian man 'had already acquired the capacity to become most Russian only when he was at his most European'. Certainly this is the most European city in Russia, and it has created its own special culture, in which revolution has flourished alongside great literature, in which an artistic and intellectual tradition of complete originality has been forged. This culture is unquestionably peculiar to the city and depends on its own mythology as much as its physical beauty.

4- Saint Petersburg Monument to Catherine the Great in the garden near the Alexandrinsky Theatre, 1873 Sculptors Matvei Chizhov and Alexander Opekushin

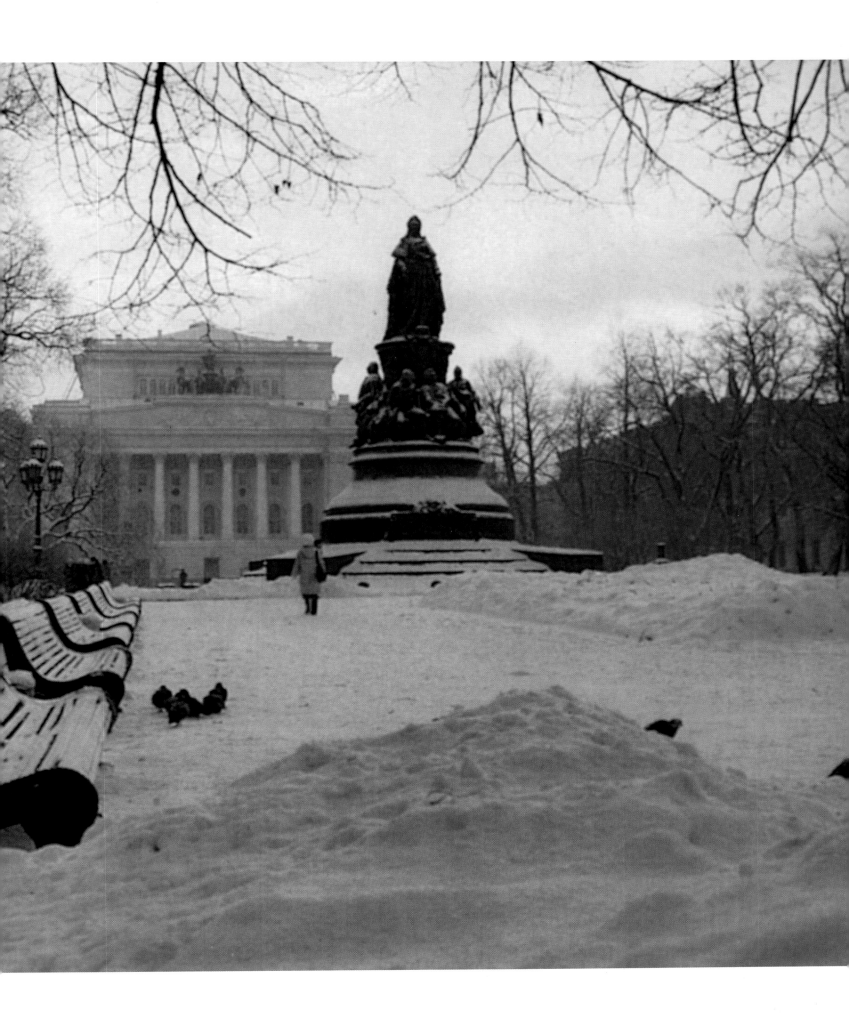

W hat is this strange conception of "beauty", which seems so simple to those who talk without thinking, but in defining which all the philosophers of various tendencies and different nationalities can in a century and a half come to no agreement? What is this conception of beauty on which the dominant doctrine of art rests?

'In Russian, by the word *krasotá* [beauty] we mean only that which pleases the sight.'
(Leo Tolstoy, "What is Art?")

Russian landscape painting did not start to develop until the early 19th century, somewhat later than its counterpart in other European countries. Portraiture tended to dominate in the latter years of the 18th century, and French influence prevailed: the Academy of Fine Arts, founded in St Petersburg in 1757, was staffed mainly by French teachers.

With the advent early in the new century of Romanticism – a movement that gained strength in Russia from the nationalistic fervour following Napoleon's defeat – came a new reverence for the land. Romantic painters, filled with the love of their countryside, felt an urgent desire to express its beauty and capture its topographical features on canvas. Karl Brüllov (1799–1852) was considered one of the leading exponents of genre, but it was Ivan Aïvazovski who came to the fore with his evocative seascapes (see p. [15] [111]), the best of which are more than a little Turneresque in style. The Society for the

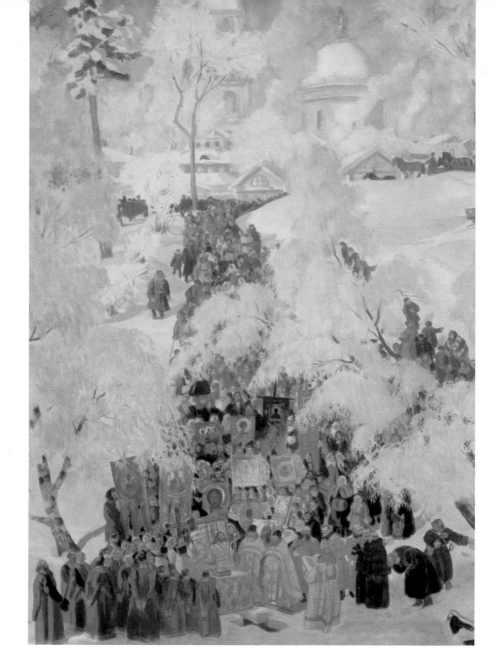

111- Boris Kustodiev

The consecration of the Waters at Epiphany, 1921 Oil on canvas. 89 x 74 cm Piotr Kapitsa collection, Moscow

Encouragement of the Arts was set up in St Petersburg in the course of the 1820s, and in some respects provided a seedbed for later developments.

Towards the middle years of the 19th century a new current became discernible, sweeping away the somewhat self-indulgent excesses into which late Romanticism had declined. This new realism became the defining mood of the mid-century in all areas of the arts, in particular literature and painting. It reflected the shift in the political climate that was now noticeable. The emancipation of serfs was yet again mooted, and an urge to a more democratic form of government was developing, in the teeth of opposition from a vast army of bureaucrats and petty officials. Alexander Pushkin produced a stream

34- Illarion Prianishnikov

Returning from the Market,
1872
Oil on canvas. 48 x 71 cm
Tretyakov Gallery, Moscow

43- Mikhail Klodt

In the Ploughed Field, 1871
Oil on canvas.
47.5 x 81.5 cm
Russian Museum, St.
Petersburg

44

of stories, poems and verse dramas in his short life, and Nikolai Gogol wrote novels, stories and plays, all informed by these fresh ideals. In the fine arts, the conflict between the old guard, the adherents of the St Petersburg Academy, and the younger artists driven by the forces of innovation reached flashpoint. Feeling stifled, unable to give free expression to their most deeply held beliefs, fourteen young members of the Academy seceded and formed the Artists' Artel in 1863. A less revolutionary but still influential body, the Society of Art Lovers, came into being in Moscow at around the same time.

From these associations the Society for Itinerant Art Exhibitions was born. Its founding members were Grigory Miasoyedov (1844–1911), who first conceived the idea for

62- Ivan Shishkin

A Stroll in the Forest, 1869
Oil on canvas.
34.3 x 43.3 cm
Tretyakov Gallery, Moscow

59- Ivan Shishkin

Evening, 1871
Oil on canvas. 71 x 44 cm
Tretyakov Gallery, Moscow

45

such a group in 1867, and Vasily Perov (1834–82), who collaborated enthusiastically in setting it up, and who was to be one of the finest painters the Society produced. Illarion Prianishnikov and Alexei Savrasov (1830–97) were also involved from the beginning. The aims of the Society were threefold: to take art to all those in the provinces

47

who could not normally get to exhibitions; to foster an appreciation of art; and to help the members sell their work.

The first exhibition took place in St Petersburg in 1871, and travelled to Moscow a few months later. Savrasov's The Rooks have Returned [41] and Prianishnikov's Returning Empty from the Market [34] were among the best of the works shown. The Prianishnikov, a

189- Valentin Serov

Autumn Evening :
Domotkanovo, 1886
Oil on canvas. 54 x 71 cm
Tretyakov Gallery, Moscow

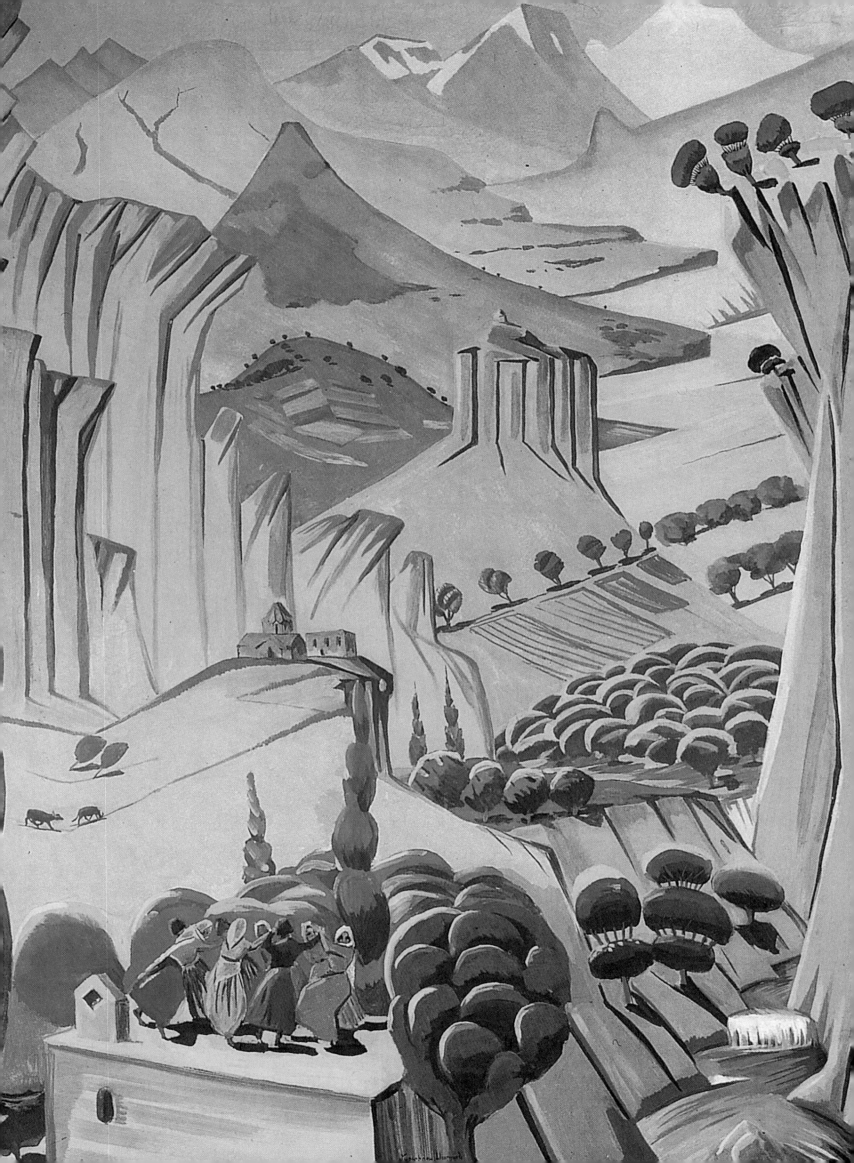

snowy sunset scene, conveys something of the satisfaction of a day's work well done, as the horses trot wearily through the snow and the dog snuffles about hopefully. At the same time the drooping head of the foreground figure betrays that he is too exhausted to enjoy the wonderful sunset. A fellow artist wrote of the Savrasov, comparing it with others in the show, that 'there is soul only in the rooks'. The delicate tracery of the birch trees, outlined against the cloudy spring sky, rises above the snow melting into puddles, while the busy activity of the noisy rooks building their nests (one can almost hear them) is an affirmation of life returning once more to the countryside.

It was inevitable that the Society would find itself on a collision course with the Academy. Its aims were greatly at variance with those of the senior establishment, and it was run on quite different principles: its board was made up of practising artists and had to be elected annually, so that no one figure could take control of its affairs. The rift occurred in 1874 when the Society refused an offer to hold joint exhibitions with the Academy, which promptly broke off relations. However, this period of estrangement lasted only twenty years or so, and fences were finally mended when four of the Society's members (Repin, Shishkin, Kuinji and Makovsky) became professors at the Academy in the 1890s.[160]

Among the finest painters to be found in the ranks of the Itinerants were Ilya Repin (1844–1930), Vasily Perov (1834–82), Ivan Shishkin (1832–98) [57, 59, 60, 62, 68] and Vasily Surikov (1848–1916); from a slightly later generation, Isaac Levitan (1860–1941) [168, 177] and Valentin Serov (1865–1911) [189]. All of these painted landscapes, but Shishkin and Levitan concentrated almost exclusively on them. It is hardly surprising that they, along with the Armenian Martiros Saryan (1880–1972) [138, 139, 145], are most heavily represented in this book. Many of the Itinerant painters were strongly influenced by the current of

53

Above:
133- Vasily Kandinsky

Suburbs of Moscow
Oil on canvas mounted on
carboard. 26.2 x 25.2 cm
Tretyakov Gallery, Moscow

Impressionism flowing in from France.

By the 1890s the Society was running out of steam; instead, the baton of progressiveness was taken up by a remarkable new St Petersburg movement, Mir Iskusstva (The World of Art), which carried the stylistic precepts of Art Nouveau into Russia. With the emergence of this new aesthetic, traditional values and forms swiftly became outmoded. Serov and Levitan gravitated towards the new style, Levitan's landscapes in particular developing a fresh lyricism. The World of Art was to a large extent the creation of Sergei Diaghilev (1872–1929), later to be a world-famous impresario; its founders included Alexander Benois (1870–1960) and Konstantin Somov (1869–1939). It soon embraced some of the leading Moscow artists, such as Levitan, Serov and Mikhail Nestorov (1862–1942). Other notable adherents were Nikolai Roerich (1874–1947), Anna Ostroumova-Lebedeva [190], Mstislav Dobuzhinsky (1875–1957) and Igor Grabar (1871–1960). [92, 124]

The Revolution of 1917 brought dramatic changes in artistic development as in every aspect of existence in Russia. Radical painters led by Kasimir Malevich (1878–1935) happily embraced the revolutionary ideals, and another new movement – Suprematism – was born. Vasily Kandinsky [133] stood a little apart from all this. A true radical, he nevertheless spent much time outside Russia and contributed only intermittently to its artistic life. Other painters working in the early years of the 20th century such as Mikhail Larionov (1881–1963) [184] were heavily influenced by French Impressionism and, later, Cubism. Like Kandinsky, Marc Chagall (1887–1985) [96] also spent most of his creative life outside Russia, apart from eight years over the Revolutionary period in which he set up an academy. All of these artists, in their own very different ways, managed to capture something of the spirit of Russia, that great phenomenon which is in the end indefinable but absolutely unmistakable. Their finest

work can be said to give physical expression to every aspect of the Russian soul.

Russia displays a sharper, more violent contrast between the seasons than most countries. In musical terms, nothing can more perfectly encapsulate the changing face of the year than Vivaldi's 'Four Seasons', but native Russian composers too have pictured Nature's ever-changing countenance – think of Glazunov's Seasons, or the Seasons variations in Prokofiev's ballet Cinderella. In the next sections we shall examine the work of numerous artists, not only those mentioned above but also many others, who reveal tremendous variety of style and approach as they respond to the beauties of the seasonal round: the awakening of the year as nature casts off her heavy blanket of snow and ice; the colours, scents and lushness of summer fields as farmers and peasants work on the land; the palpable aura of sadness at autumn's dying brilliance; and the chill of winter, misty and mysterious in the city or crisp and bright in the country where the Snow Maiden reigns.

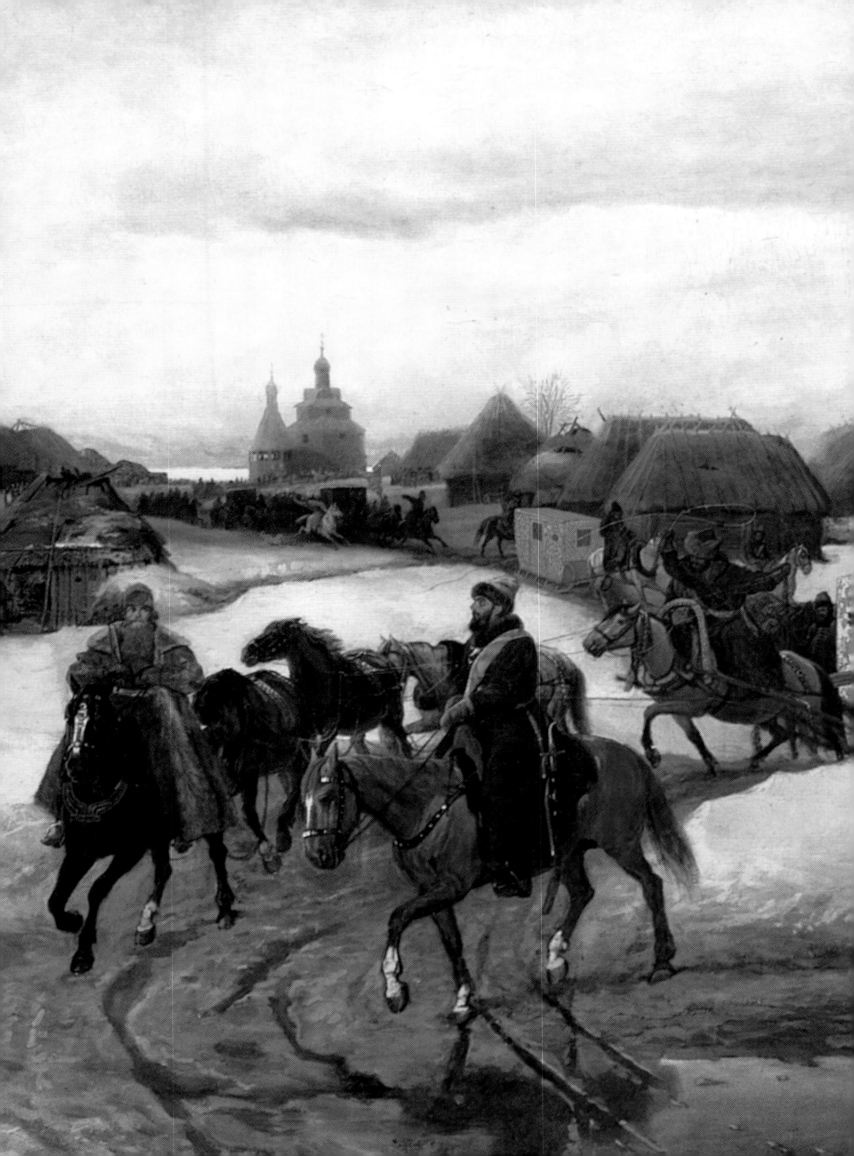

The Year Reborn:

SPRING

When it arrives the Russian spring is harsh and dramatic, unlike the soft, gentle season familiar to most people in Western Europe. Natural forces too strong to be contained transform the land. The 'ice-break' is the moment Russians long for, when the grip of winter and its sub-zero temperatures at last start to give way to the first traces of warmth and the soul can breathe in the promise of summer days to come.

Once the ice starts to melt, travelling becomes a perilous undertaking. Flooding is frequent – rivers burst their banks, lakes overflow, roads and fields are covered in treacherous mud, making conditions hazardous for the strong, patient pack animals as they battle to pull their heavy loads.

Russian landscapists have always been superlative at pinpointing these early moments of change. Viacheslav Schwarz (1838–69), one of the first to develop the history and genre painting of the early 19th century in a more Realist direction following the decay of Romanticism, painted The Tsarina's Spring Pilgrimage in the Reign of Alexei Mikhailovich in 1868 [24]. (The reign in question occupied the third quarter of the 17th century.) The picture captures the moment of struggle when the heavy coach is hauled up the steep, icy slope. The horses strain every muscle as the whip curls menacingly above them.

24- Viacheslav Schwarz
The Tsarina's Spring
Pilgrimage in the Reign of
Alexei Mikhailovich, 1868

59

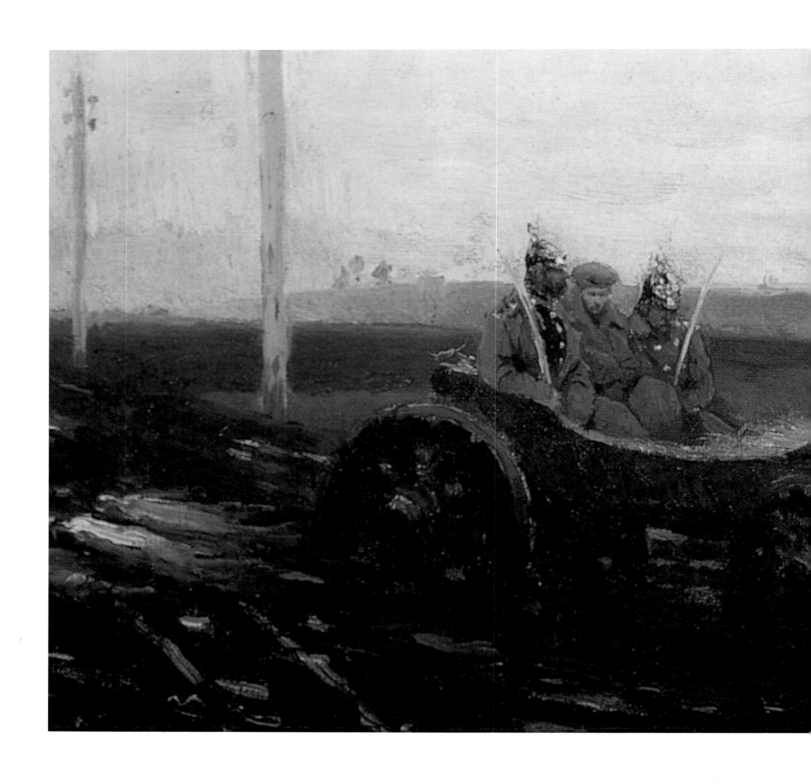

161- Ilya Repin

Under Guard, Along the
Muddy Road, 1876
Oil on canvas. 26.5 x 53 cm
Tretyakov Gallery, Moscow

The Tsarina's coach bears the eagle emblem on the front –
Schwarz was noted for his attention to detail, and took a
pride in representing specific historic occasions with
enormous accuracy.

A little later in the year, as the rains begin, country
roads glisten with a thick, viscous sludge and the mud
becomes all-enveloping. Such conditions moved Ilya

48- Ilya Ostroukhov

Early Spring, 1891
Oil on canvas.
61.2 x 49.4 cm
Art Museum, Yaroslav

47- Isaac Levitan

March, 1895
Oil on canvas. 60 x 75 cm
Tretyakov Gallery, Moscow

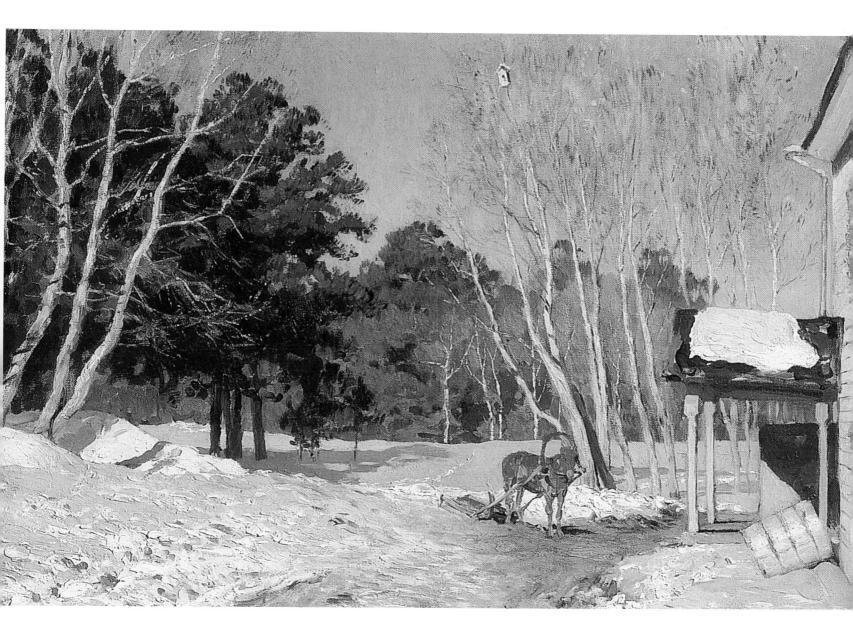

Repin (1844–1930) to produce Under Guard, Along the Muddy Road (1876) [161], a genre picture in which the dark colours and sketchy brushwork focus attention on the misery in the prisoner's face. Repin was a man who understood the necessity, almost the duty, of expressing in paint the soul of his native land. His works developed out

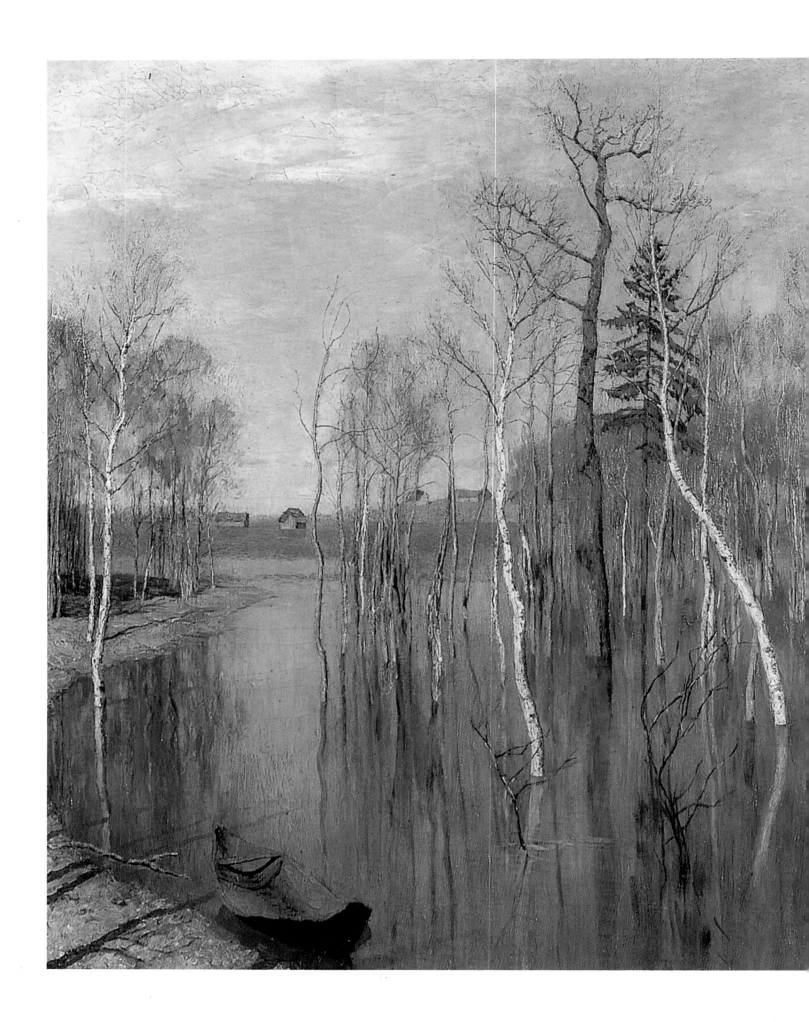

of the spiritual sphere which he inhabited somewhere between the 'idea' and the 'soil'. He often worked directly from a real-life scene, but equally often sought themes from Russian history, or drew inspiration from his perception of the individual's destiny, both in life and in the hereafter.

Ilya Ostroukhov (1858–1929), one of Repin's students, catches the melting of the ice in his exquisite Early Spring [48]. The crystal clarity of the scene is softened by touches of pale yellow in the sky and the receding snow, while the trees in the foreground make an effective frame for the distant river and fields.

One of the greatest landscape artists of the 19th century is Isaac Levitan (1860–1941); he holds a prime position not simply in Russia but in the whole of Europe. Born in Lithuania, he went to Moscow with his family and attended the Academy there. Early on he was influenced by the works of the French Barbizon school, especially Corot, and copied many of their pictures that he saw in Russian art collections. His love of nature was fostered by his teachers, first Savrasov and later Vasily Polenov (1844–1927), a fine landscapist in his own right who was soon outstripped by his pupil. He joined the Itinerants in 1891, and thereafter concentrated on what he most wanted to do: to reveal the distinctive character of the Russian landscape in all its guises. He was able to consolidate the achievements of the preceding generation, who included Shishkin as well as his teachers. He was not restricted to one style or mood: look at the contrasts among his spring landscapes. The dazzling March (1895 [47]) is so crisp and bright that the viewer can as it were smell the pines, breathing in the sharp, cold air while feeling the sun's warmth on his back. A little later in the year, the warm blue of the sky reflected in the overflowing river in Spring. Flood Water [15] invests the scene with a tender poetry. Behind their representation of Russian nature is a grasp of its inner soul which comes across so

65

forcefully that these two paintings can be called 'national landscapes' – they are the very essence of the Russian spring.

A quite different, more Impressionistic mood pervades the little painting of Spring, The Last Snows [17], which is so thinly painted that the canvas shows through. Neither

this nor Flood Waters [11] has the joyousness of the 'blue and white' pictures: there is an air of melancholy, even of danger in the waters which will leave such chaos as they recede. The same slight melancholy breathes from the sketch of Spring, Storks in the Sky [167], although the heart-lifting sight of a flight of birds above the vast expanse of

17- Isaac Levitan

Spring, The Last Snow, 189
Oil on canvas.
25.5 x 33.3 cm
Russian Museum,
St. Petersburg

11- Isaac Levitan
Flood Waters, 1885
Oil on canvas. 94 x 157 cm
Art Museum of Byelorussia,
Minsk

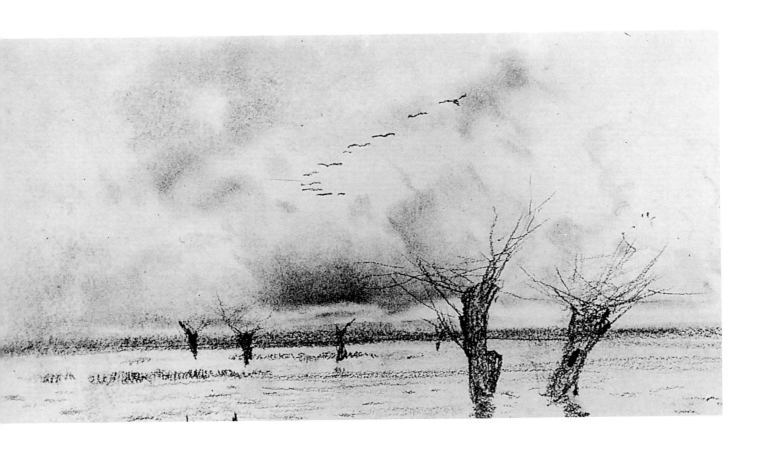

167- Isaac Levitan

Storks in Sky, Spring, 1880s
Watercolor on paper.
16.2 x 24.7 cm
Private collection, Moscow

13- Isaac Levitan

The Sura from the High
Bank, 1887
Oil on paper mounted. 20 x
34,5 cm
Picture Gallery, Tver

flood-water is a cheering sign of the coming season.[13]

Towns could also call forth attractive compositions from Levitan's brush. Boulevard in the Evening [10] is touched with a little magic as the walking couple are swathed in the misty, greenish light reflected from the melting snow. Later on, when the trees begin to burgeon, Levitan captures this change of mood, a distinct shift in the country-dweller's perceptions. Spring in the Wood [171] is one of many examples of this style, a highly Romantic painting in which the lush grass on the banks of the slow-flowing stream cushions the footfall of any creature, human or animal, that dares to penetrate the mysteries of the woodland. One can imagine Prince Andrei in Tolstoy's 'War and Peace' riding through such a forest:

'They went through the muddy village, past threshing-floors and green fields of winter rye, downhill where snow still lodged near the bridge, uphill where the clay had been liquefied by the rain, past strips of stubble

10- Isaac Levitan

*Boulevard in the Evening, 1883
Oil on canvas. 20 x 32 cm
Picture Gallery of Armenia, Yerevan*

171- Isaac Levitan

Spring in the Wood, 1882
Oil on canvas.
43.4 x 35.7 cm
Tretyakov Gallery, Moscow

70

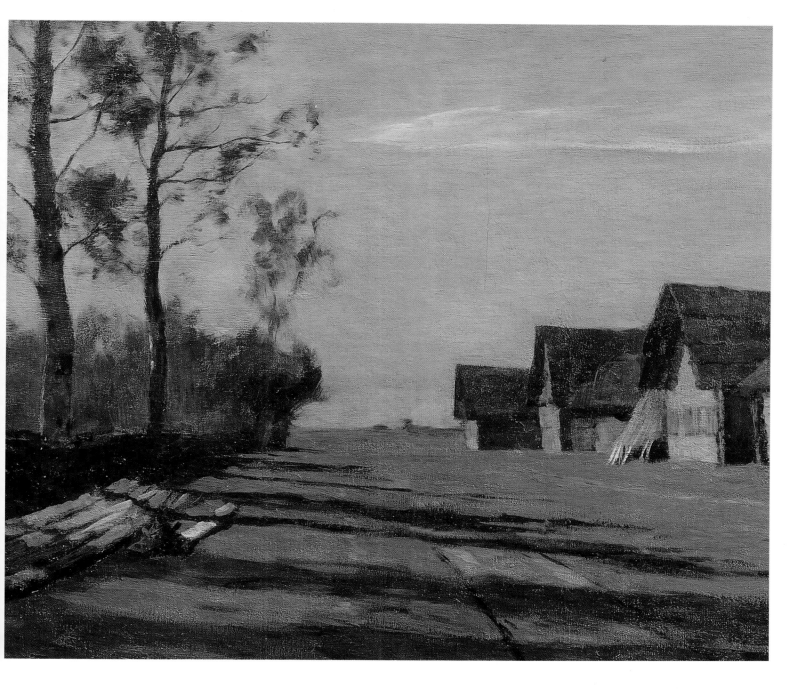

land and bushes touched with green here and there, and into a birch forest growing on both sides of the road. In the forest it was almost hot, no wind could be felt. The birches with their sticky green leaves were motionless, and lilac-coloured flowers and the first blades of green grass were pushing up and lifting last year's leaves.'

A village by moonlight [19] is equally mysterious – only one house has a light in its window as the village huddles under the milky green sky.[166]

Levitan's work reveals a spirituality that derives from

19- Isaac Levitan

Village by Moonlight, 1897
Oil on canvas. 60 x 90.5 cm
Russian Museum, St.
Petersburg

his preoccupation with the meaning of mankind's existence. His love of the beauties of his country shines through everything he does and is transferred on to the

canvas: the wind in the trees, the rushing of water, even, as he once said, the sound of the grass growing. To know and love his work is to understand much about the Russian soul which is our quest. Alexander Benois said of him, '... he understood the obscure charm of Russian nature, its secret meaning. That is all he understood, but he did so like no one else.'[172]

The spring thaw was a perennial source of inspiration for painters of all kinds. Stanislav Zhukovsky (1873–1944) belonged to the school of Russian Impressionism, whose adherents shared the French Impressionists' love of the outdoors, their completely new

artistic perceptions, their spontaneity and ability to improvise. Two paintings of 1898 show an intense lyricism that invites us into the heart of the Russian landscape. The icy blue tones of Spring Water [49] draw the viewer along the rutted road towards the distant promise of summer, still only a pale yellow-green patch in the distance. The darkly glowing lake among the trees (Spring Floods [178]) contrasts with the sun-dappled floor of the forest where already the first buds can be imagined thrusting up through the bare earth. The Dike [86] shows a powerful treatment of the still, reflective water, only the odd ripple betraying the thaw that is imperceptibly beginning. Spring is almost ready to yield to summer in the very Impressionistic urban setting of The White House [87], a painting full of the warmth of the sun, radiant with happy feelings.

In a completely contrasting mood, Constantin Yuon uses the

49- Stanislav Zhukovsky

Spring Water, 1898
Oil on canvas. 78 x 121 cm
Russian Museum,
St. Petersburg

178- Stanislav Jukovsky

Spring Floods, 1898
Tretyakov Gallery, Moscow

86- Stanislav Jukovski

The Dike, 1909
Russian Museum,
St. Petersburg

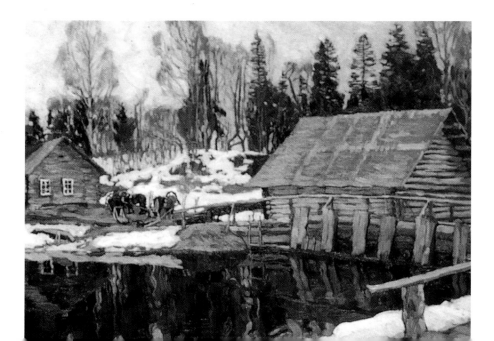

'thaw' theme in a fine townscape, when the last of the snow dramatizes the magnificent skyline of Rostov the Great [91]. His use of colour here is exquisite: the pale primrose early-morning sky throws the snowy areas into bluish shadow, while the warm terra cotta of the fabled architecture acts as a foil. Another version of the spring thaw [90] in March Sun (1910) takes us to the edge of a village where people

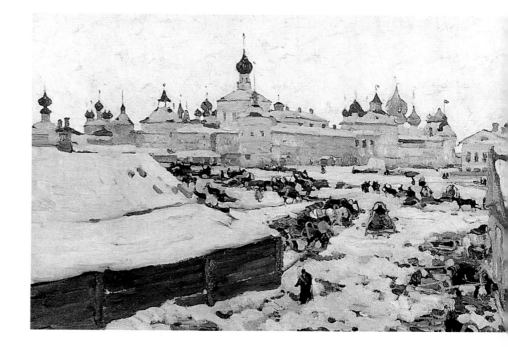

hurry about their business as children play and chickens scratch around in the wet snow. It is a sprightly scene, full of optimism, the fresh blue of the sky nicely setting off

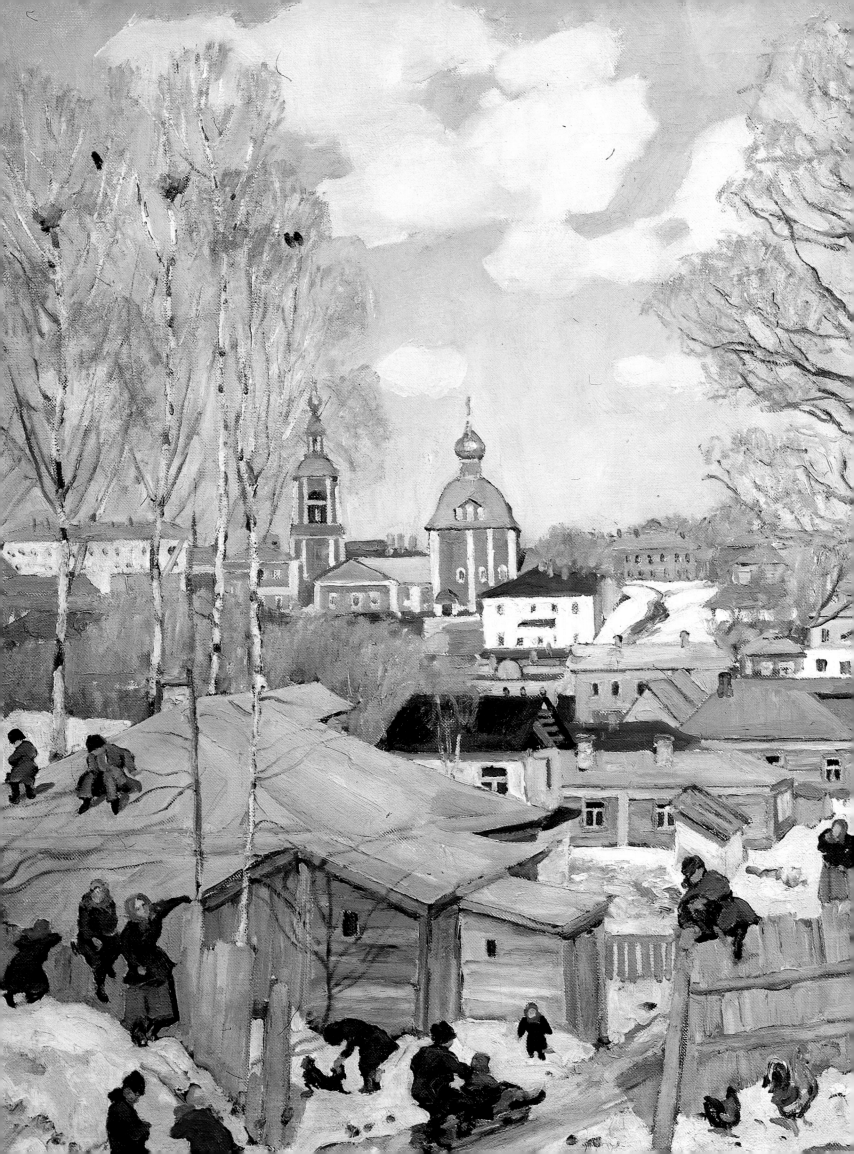

Preceeding pages:
90- Constantin Yuon

March Sun, 1910
Tretyakov Gallery, Moscow

Right:
82- Sergei Vinogradov

Martzianovo Village, 1902

Below:
50- Fjodor Vasiljev

The Thaw, 1871

the earthy tones of the buildings that make up the attractive little town.

Minor landscape artists give expression to the love of the land in their own way. In Feodor Vasilyev's depiction of The Thaw [50], a father and his child, heavily wrapped up, point at the birds flocking to find food in the newly uncovered ground. The broad sweep of the fields stretches

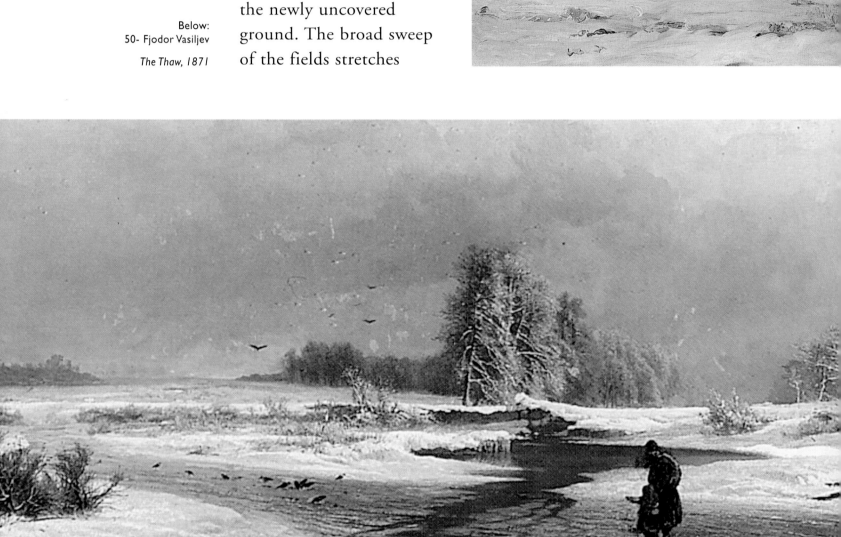

78

away under a threatening sky, which nevertheless holds a faint suspicion of better weather to come. Sergei Vinogradov (1869–1938), like Zhukovsky, was a student of Polenov, and like him embraced étudisme, the practice of painting out of doors not as a basis for a later, finished work but creating the work on the spot. His view of Martzianovo Village in the early spring sunshine, painted in 1902 [82], is still strongly Impressionist and avoids the later decline into mere decorative colourism into which some of this group of painters found themselves sinking.

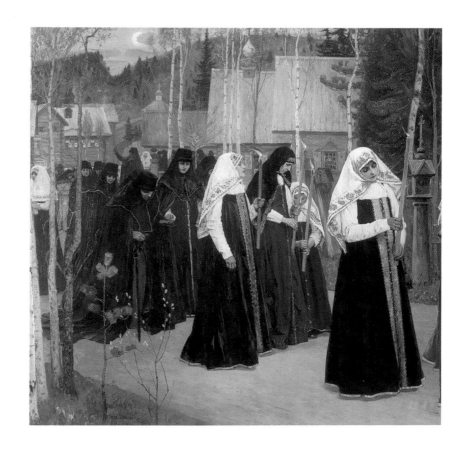

A deep and simple piety has always been an important strand in the make-up of the Russian soul. Even during the Soviet era it remained in the psyche, a strong pulse underground, never daring to show a public face but never quite extinguished. Mikhail Nesterov (1862–1942) taps into this vein with The Taking of the Veil [38], a neo-Romantic work showing the strong influence of such French painters as Jules Bastien-Lepage and Pierre Puvis de Chavannes. The rich blacks against the quiet sunset background, the pious old nun in the middle ground, the serious, exalted expressions on the faces of the postulants, all achieve the painter's aim to depict 'the soul of the people'. A very secular couple portray a different kind of love in Kuzma Petrov-Vodkin's Spring of 1935 [123]. The

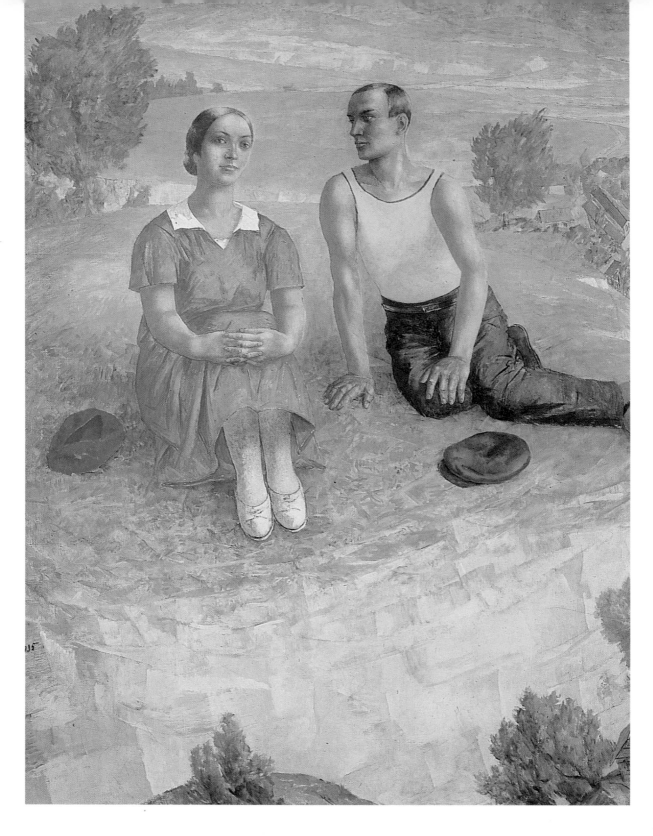

123- Kuzma Petrov Vodkin

Spring, 1935
Oil on canvas. 186 x 159 c

atmosphere of the painting breathes the same spirit that Maxim Gorky's grandmother conjured up when she told him: 'It's marvellous to be in the open in the spring and summer. The ground's warm and soft, the grass like velvet! The Holy Virgin has sprinkled the fields with flowers. It fills you with joy and leaves room for the soul to breathe' (from 'My Childhood'). Petrov-Vodkin (1878–1939)

80

sought a 'national' colourism, which he achieved through the painterly harmonies he derived from ancient Russian frescoes.

One of the most remarkable artists to be represented in these pages is Martiros Saryan (1880–1972). We shall say more about him in the next section, since much of his work is the quintessence of summer, but Saryan, the

144- Martiros Saryan

Sunrise over Ararat, 1923
Oil on canvas pastel on
carboard. 23 x 36 cm
Lunacharskaya collection,
Moscow

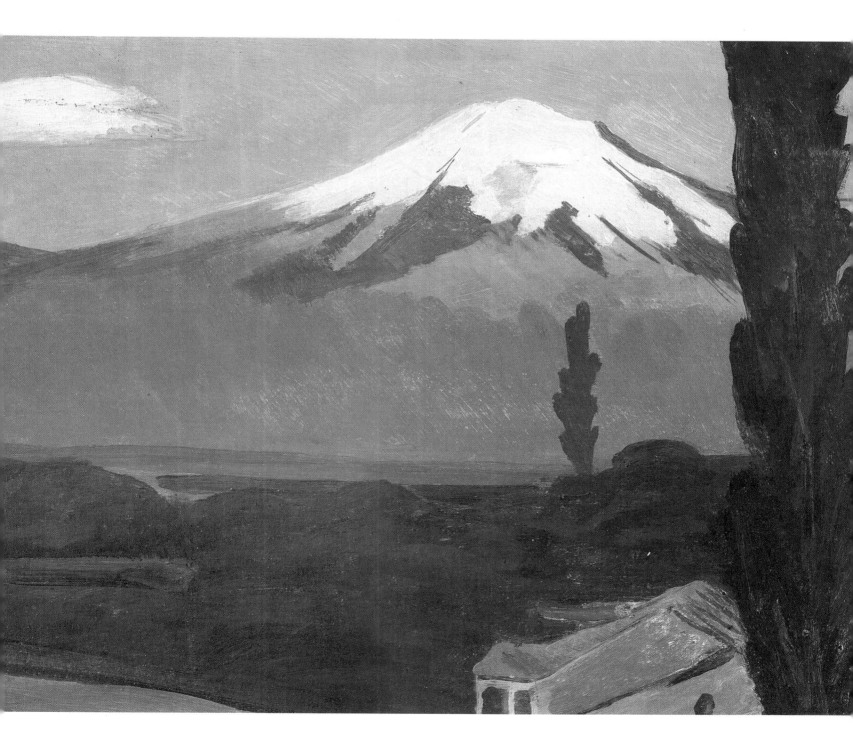

supreme painter of Armenia and unequalled in his glowing renditions of southern colour, painted also many superb land- and townscapes of spring. Among his favourite themes are the mountain peaks of Ararat and Aragats, on the border with Turkey [144, 153, 154], which he painted at all seasons of the year. Earlier in his career he embraced Symbolism, with its yearning for a more spiritual, less mundane view of the world, its desire to

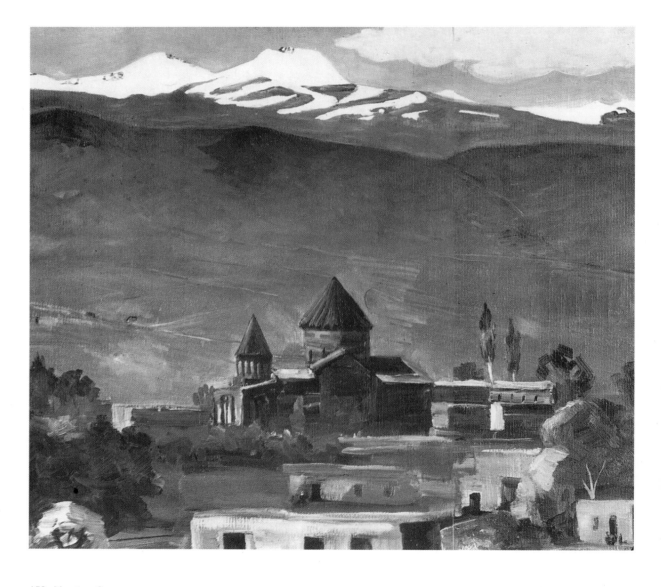

153- Martiros Saryan

Mugni and Aragats in Spring, 1951
Oil on canvas. 53 x 72 cm
A. Alikhanov Family collection, Moscow

154- Martiros Saryan

Precipice on the Slope of Mount Aragats, 1958
Oil on canvas.
80 x 100 cm
L. Saryan collection, Yerevan

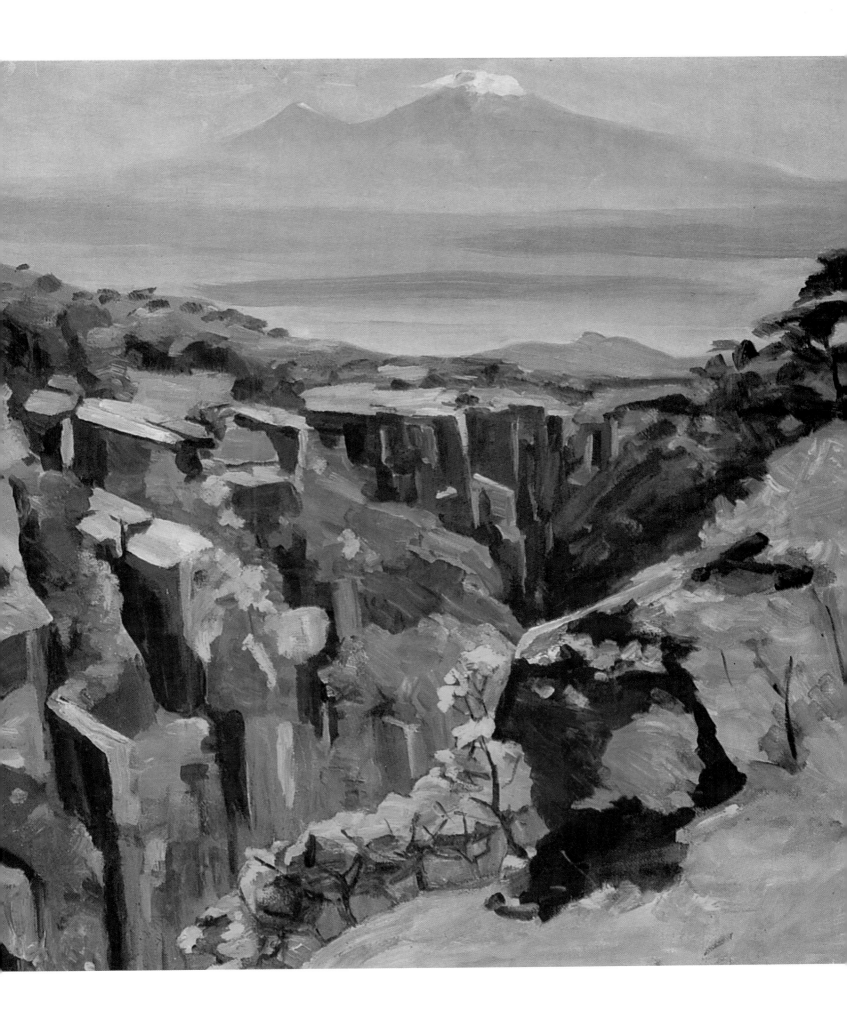

136- Martiros Saryan

Mountains in Bloom, in the Gorge of Akhurian, 1905 Watercolor on paper. 67 x 66 cm Martiros Saryan Museum, Yerevan

penetrate the very marrow of human existence. His fantasy painting A Fairy-Tale By the Tree[135] and the no less Symbolist Mountains in Bloom, In the Gorge of Akhurian [136] take us into a mystic realm where the light is soft and crepuscular, where animals and birds take on anthropomorphic qualities.

The names of Kasimir Malevich (1878–1935) and

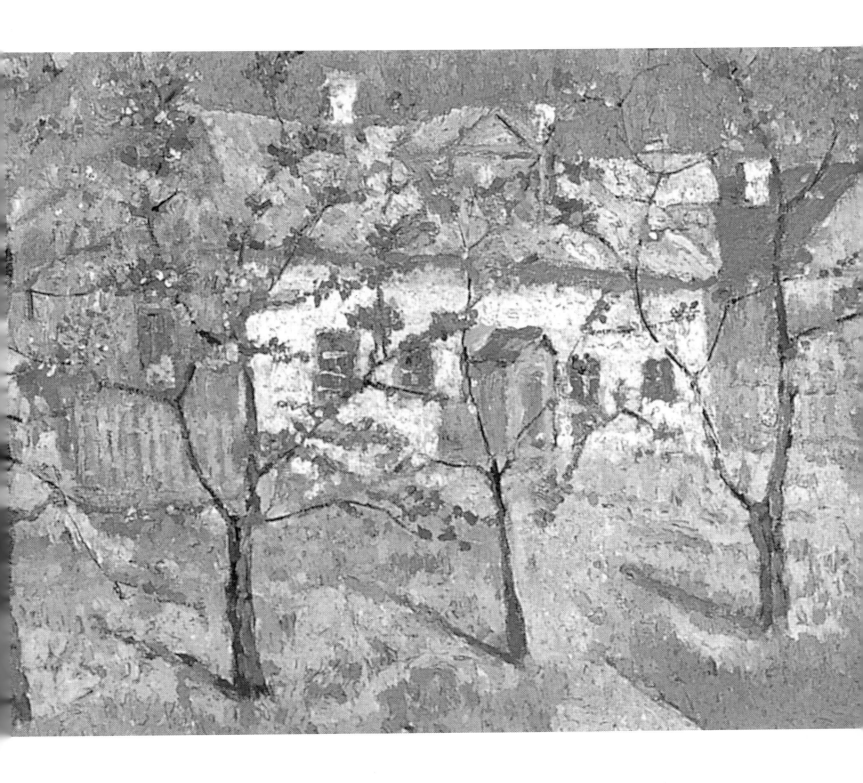

Mikhail Larionov (1881–1963) do not readily spring to mind in connection with Impressionism. Yet both produced early works of great charm which bear the unmistakable stamp of an Impressionist aesthetic. Malevich's later radicalism had its roots in the independence he acquired from this early adherence. The influence of Pissarro and Cézanne is discernible in Spring

181-Kasimir Malevich

Spring-gardens in Bloom,
1904
Russian Museum,
St. Petersburg

– Gardens in Bloom[181], with its sunny, light-toned palette and quasi-Pointilliste technique. Larionov's Acacias in Spring[184] is in similar vein, and was painted in the same year (1904). It is a masterpiece of tender translucency, the pale shimmer of the treetops vibrating with the joyous light and life of the new season. By 1905 his style had altered dramatically and he entered his Primitivist phase. Such paintings as Sunset after Rain, painted in 1908[186], with its blobs and smears of vivid colour reminiscent of folk-art, provided a creative well-spring from which many of his fellow artists were to take nourishment.

The last of our artists to gain inspiration from the miracle of spring is Marc Chagall (1887–1985). His well-known I and the Village (1911) is a many-layered work, harmonizing the direct, child-like quality of the figures and houses with a fantastic imagination which is somehow quite matter-of-fact. The sprig of blossom in the foreground (detail[97]) becomes a complete tree, containing

97- Marc Chagall

*I and the Village (detail),
1911
Oil on canvas.
191.2 x 150.5 cm
Museum of Modern Art,
New-York*

in its leaves all the joyful manifestations of a Russian spring. The Dacha [100] of seven years later is, on the face of it, more naturalistic, but the curves of fence and path hark back to the impression of the earth's curvature that is so marked a feature of the earlier work. The glowing greens are an invitation to revel in the happiness of spring: 'Everything was fermenting, growing, rising with the yeast of life. The joy of living, like a still wind, swept in a tidal wave indiscriminately through fields and towns, through walls and fences, through wood and flesh' (Pasternak, Doctor Zhivago).

100- Marc Chagall

The Dacha, 1918
Oil on cardboard.
60.5 x 46 cm
Picture Gallery of Armenia,
Yerevan

When the earth expands

SUMMER

'It was the time of the year, the very top of the
summer, when the prospects of harvest may be
estimated ... when the rye is already eared and sea-
green in colour, but still not fully formed; when the
ears of corn swing lightly in the breeze; when the
green oats, with scattered clumps of yellow grass, peep
irregularly from the late-sown fields ... when the
odour of the dry manure, heaped in little hillocks
over the fields, mingles at twilight with the perfume
of the honey-grass, and on the bottom lands, waiting
for the scythe, stand the protected meadows like a
boundless sea with the darkening clumps of sorrel
that has done blooming.'

Tolstoy, *Anna Karenina*

Summer is the time when the earth expands, when the sun-god Yarilo comes into his kingdom. The Russian summer is all too brief, and the peasant must work hard to make the most of it. But everyone, high or low, loves the warmth, the release from the captivity of the ice. Flowers are there in abundance for the picking, fruit and crops ripen, women can wear pretty dresses.

In the 19th century, nine-tenths of Russians lived on the land: the soul of the Russian peasant could be said to emanate from the village. Peasant life had been hard since

26- Grigory Miasoyedov

The Busy Season (Mowers),
1887
Oil on canvas. 179 x 275 cm
Russian Museum,
St. Petersburg

time immemorial. Various Tsars made efforts, sometimes totally ineffectual, to improve matters; steps were taken towards abolishing serfdom in the early years of the century, during Alexander I's reign, and Nicholas I recognized the need to raise the status of those who worked the land. But an autocratic form of government, underpinned by bureaucracy and supported by the landowning classes, meant an uphill struggle to achieve reform. The fear of rebellion, however, was exaggerated; there was a saying that 'while the Russian peasant's hoe is in the ground he will not rise up'.

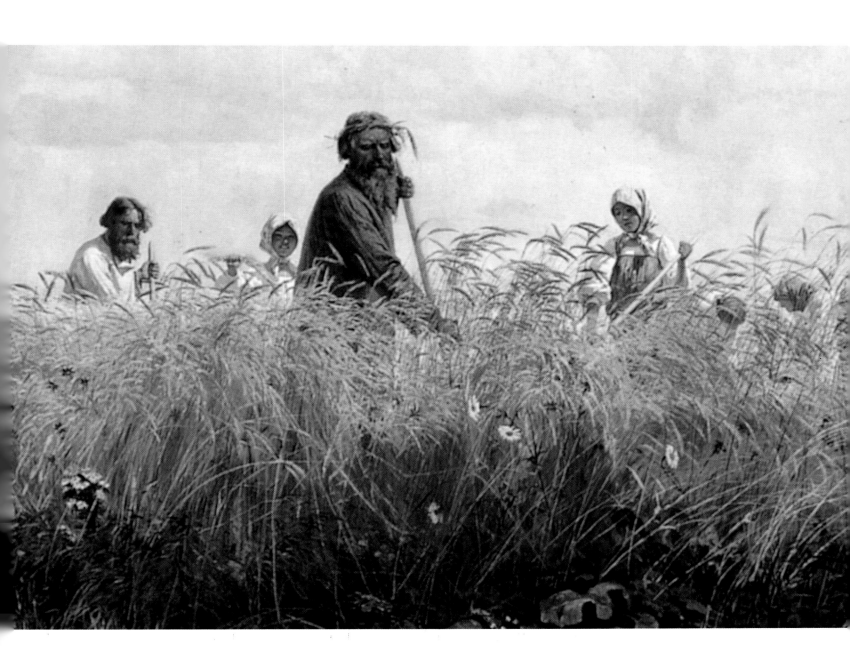

Grigory Miasoyedov idealizes his peasants in The Busy Season (Mowers) [26]. They are fine-looking men and women, proud of their strength as they cut the corn with sweeping, rhythmic movements. This painting, considered to be the artist's finest, was said to be greatly appreciated by Alexander III. A critic said of it that the viewer stands

36- Vladimir Makovsky

Night Pasturing of Horses,
1879
Oil on canvas. 67 x 77 cm
Russian Museum,
St. Petersburg

'for a long time captivated by the Russian summer and the Russian field'. Vladimir Makovsky (1846–1920) recorded daily peasant life from a very different perspective, often with a touch of humour, which tends to render his canvases anecdotal at the expense of psychological

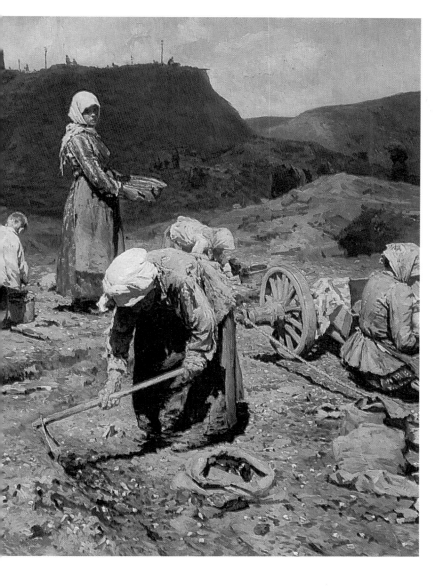

perspicacity. He can, however, bring a touching quality to his work, as in Night Pasturing of Horses [36], in which the depiction of the children in animated conversation narrowly avoids sentimentality.

In the 1880s and 1890s a new generation joined the Itinerants. Of these, Nikolai Kasatkin (1859–1930) was the one who most consistently carried on the previous generation's tradition of genre painting. Kasatkin spent many months observing the coal-miners of the Donetsk region, and it was this that inspired Poor People Collecting Coal in an Abandoned Pit of 1894 [31]. The wretched existence of these women and children is underscored by the grim grey landscape – not a touch of colour or life relieves its monotony. Weariness and a numb acceptance are expressed in the carefully arranged composition and the restrained eloquence of the tonal scheme.

Immensely more cheerful are two works by Kasimir Malevich in his early, representational mode. Reapers [183] is a bold, four-square painting from which Gauguin and Cézanne are not far away. It has the irresistible smell of summer about it. The brilliant, saturated colours are

thickly laid on; the perspective is such that we are almost inside the painting – the monumental figure in the foreground has part of a foot cut off by the frame. Fields [182] is a further exercise in bright colour, and here the impasto is so heavy that the painting does not make sense close up – only from a distance does it become

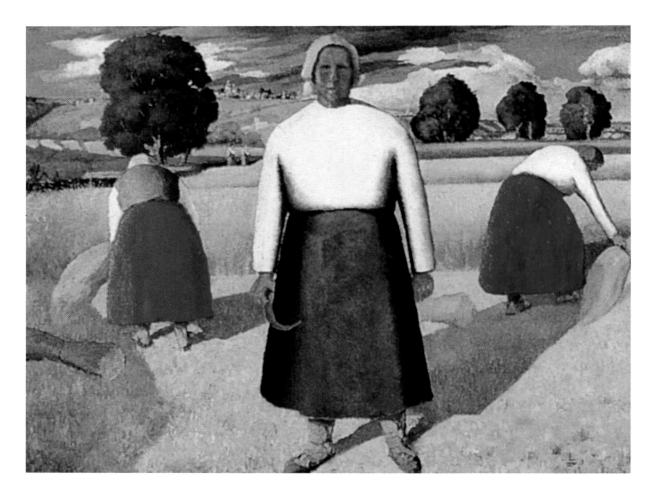

183-Kasimir Malevich

Reapers, 1909-1910 (or after 1927 ?) Russian Museum, St. Petersburg

Opposite: 182-Kasimir Malevich

Fields Russian Museum, St. Petersburg

apparent that the thick green splodges are a belt of trees. Van Gogh would certainly have felt at home with both the technique and the vibrant colour palette. Both these paintings (of either 1909/10 or 1927 – there is uncertainty about the date of these and other works in the same style) have an uncompromising structure verging on the abstract, in which may be discerned the seeds of the later Suprematism for which Malevich is best known.

A work of 1915, around more or less the same period, is a harvest scene [116] by Zinaida Serebriakova (1884–1967), a member of the World of Art association, which was closely linked to the theatre. There is something balletic about these sturdy young women in

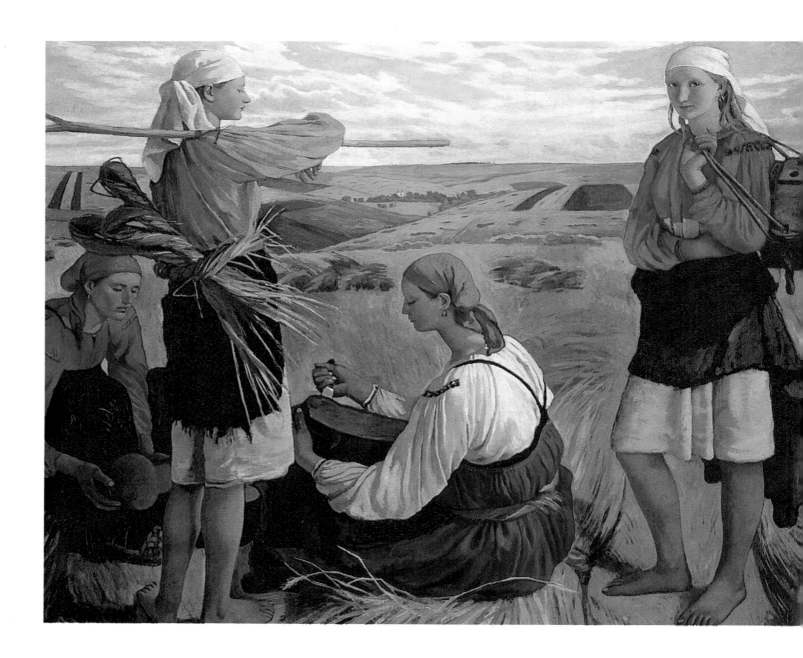

their slightly self-conscious poses. The colours are as vivid as Malevich's, but the depth of field seems odd, as though the four figures had been arranged in one plane against a stage set. There is a charm and spirit to the work, though, especially in the glance of the girl at right who seems to

116- Zinaida Serebriakova

Harvest Time
1915
Oil on canvas. 142 x 177 cm
Odessa

invite the viewer to join their simple feast. Although idealized, something of the soul of those who toil on the land comes out in this work.

The religious element that we have already seen in the spring pictures manifests itself even at the height of summer, when perhaps everyone might be thought too busy to pay attention to spiritual matters. Another picture by Illarion Prianishnikov shows how deep is the vein of piety in the Russian make-up: in A Religious Procession of 1893 [33] the congregation emerging from church must

33- Illarion Prianishnikov

A Religious Procession, 1893
Oil on canvas.
101.5 x 165 cm
Russian Museum,
St. Petersburg

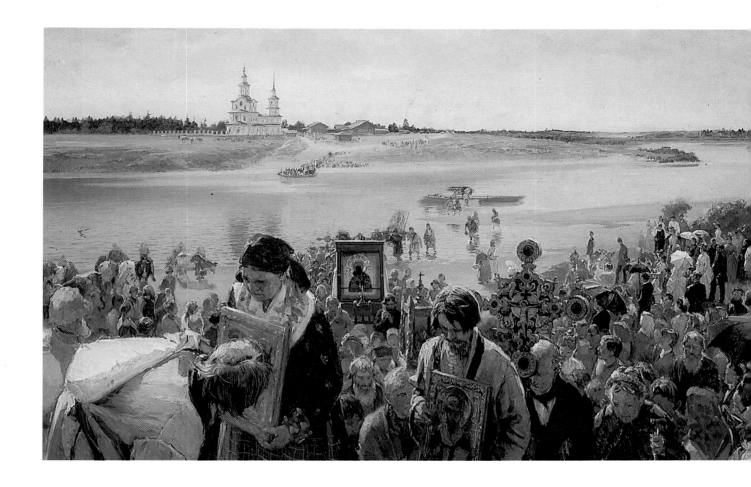

take a ferry to cross the river, but a few brave souls wade across in the hope of earning extra spiritual credit. In the young man who bends unselfconsciously to kiss the icon, in the solemn old woman who carries it, in the bowed heads of the elderly couple behind them there is nothing

but intense concentration on the matter in hand: the worship of God.

Mikhail Nesterov has tapped this pious vein to remarkable effect in his St Sergius cycle. The first painting in this series of 'Holy Russia' is The Vision of the Boy

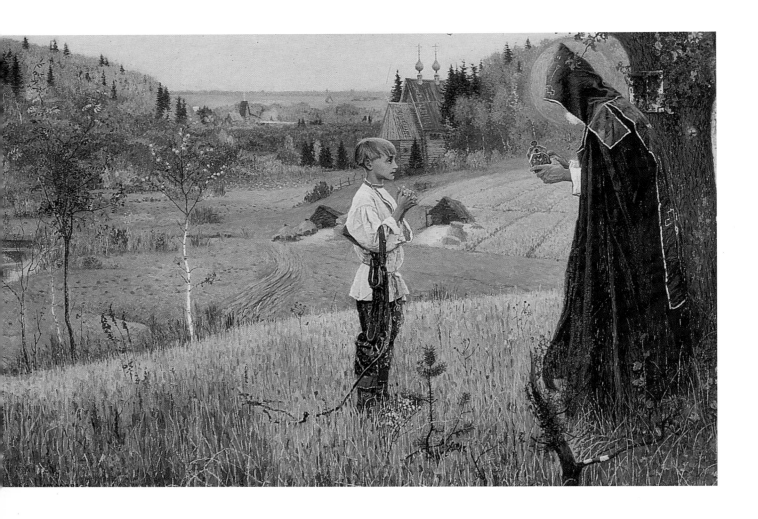

32- Mikhail Nesterov

The Vision of the Boy Bartholomew, 1889-1890 Oil on canvas. 160 x 211 cm Treyakov Gallery, Moscow

Bartholomew of 1889–90 [32]; the face of the young boy with its otherworldly pallor and huge eyes stares raptly at the vision of a monk who tells him he is destined for sainthood. The beautiful summer landscape breathes a peculiarly Russian, spiritual atmosphere that convinces us of the power of prayer. If ever miracles occur, one feels, it could be here among the flowers and grasses of the tranquil, rolling countryside. Religion, however, holds sway in the urban as much as the rural environment: in Adrian Volkov's Sennaya Square in St Petersburg of the

0- Adrian Volkov

ennaya Square in
t. Petersburg, 1860s

1860s [20] it is the enormous church that is the dominant element of the composition.

The quality of 'Russianness' is not, of course, confined to the countryside, and is as much the prerogative of the bourgeois and the aristocrat as of the peasant class. The Russian love of home and family is the theme of paintings by Vasily Maximov (All in the Past [27]) and Vasily Polenov (A Courtyard in Moscow [46]). The old women dozing or knitting in the sun, the children playing on the grass are delineated with enormous tenderness. The Polenov has become a favourite work among

27- Vasily Maximov

All is in the Past, 1889
Oil on canvas. 27 x 35 cm
Tretyakov Gallery, Moscow

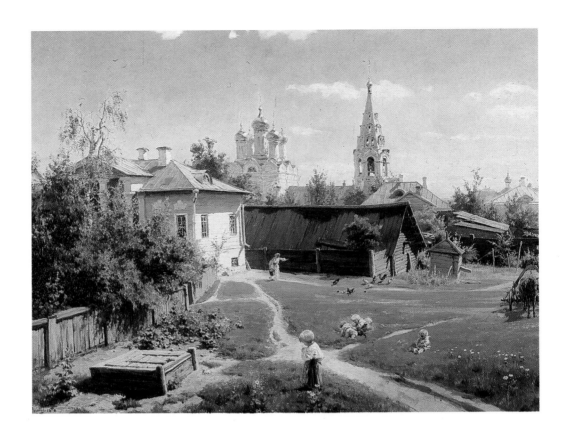

Russians for its nostalgic evocation of childhood, familiar things, the security of home. Valentin Serov (1865–1911), a great painter who bridged the 19th and 20th centuries in his stylistic blending of the traditional with the innovative, carries the homely theme further with In Summer [40], where a mother, Serov's wife in fact, sits relaxed but conscious all the time of her children as they play happily in the sun-drenched garden.

Ilya Repin absorbed many influences from the Impressionists during his sojourn in France in the mid-1870s. This shows in On the Turf Bench (1876) [78], a

14- Isaac Levitan

Golden Autumn, in the Villag
1889
Oil on canvas. 43 x 67.2 cm
Russian Museum,
St. Petersburg

40- Valentin Serov

In Summer, 1895
Oil on canvas.
73.5 x 93.8 cm
Tretyakov Gallery, Moscow

78- Ilya Rep

On the Turf Benc
Oil on canvas. 36 x 55.5 c
Russian Museun
St. Petersbur

glorious burst of light-filled paint splashed freely and
joyously on to the canvas. The composition is articulated
by concerns of space and form, which give it convincing
depth. The bourgeois family (the artist's) sits at ease in the
shade, only the girl in the white dress (Repin's wife) aware
that she is being observed. The Impressionist aesthetic still

80- Ilya Repin

*At the Academy's House in
the Country, 1898*
Oil on canvas. 64 x 106 cm
Russian Museum,
St. Petersburg

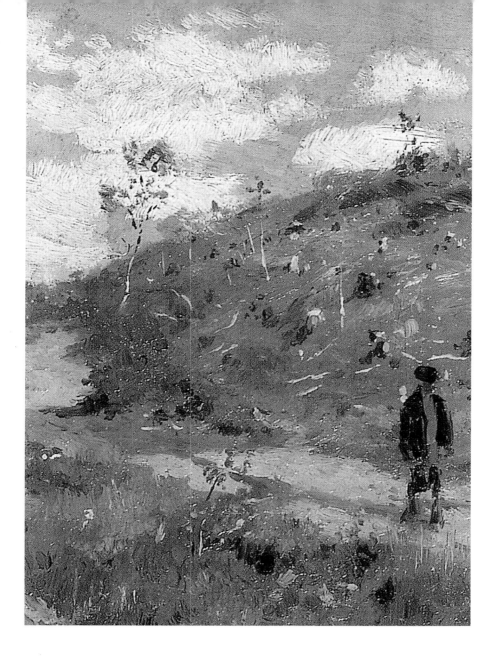

informs At the Academy's House in the Country (1898) [80], but the air of utter tranquillity is no longer quite so perfectly expressed – the busy picture with its focal point on the left and its large expanse of grassy foreground is more like a snapshot than a depiction of mood.[79]

Summer in a domestic setting is the theme chosen by Sergei Sudeikin (In the Country [197]), Stanislav Zhukovsky (The Terrace [180]) and Konstantin Somov (1869–1939). Sudeikin (1882–1946) was, like Serebriakova, a member of the World of Art group. His wonderful garden scene is the essence of summer. Zhukovsky's terrace is bathed in the light of evening – there is no blue left in the sky. Somov produces a sweet-toned pastoral in Rainbow [192], almost worthy of Marie Antoinette. Much more interesting is Firework Display of 1922 [191], in which the

79- Ilya Repin

Summer Landscape in Kurks province, 1881
Study for the painting
Religious Procession in Kurks Province, 1880-1883
Oil on card, 14 x 20 cm
Tretyakov Gallery, Moscow

197- Sergei Sudeikin

In the Country
Private collection,
St. Petersburg

180- Stanislav Jukovski

The Terrace, 1906
Russian Museum,
St. Petersburg

paint is applied in a tapestry-like manner and the golden glow of the evening sky merges into the pyrotechnic display: 'There were days when the sun would set and the sky overflowed with fiery rivers which would burn out, letting their golden-red ashes settle on the velvet green of the garden. Then one could feel everything grow darker, wider, and swell out, flooded by the warm darkness. Leaves heavy with sun would droop, the grass bent over to the ground and everything would grow softer, richer, and the air would be filled with light, caressing smells, just like music which floated in from the distant fields' (Maxim Gorky, 'My Childhood').

Marc Chagall brings his unique interpretation of domestic life to his paintings of summer. Chagall did not subscribe to an easily defined style, changing his approach constantly to suit his subject. Yet there is always something dreamlike about his townscapes, the result, no doubt, of his nostalgia for his Jewish childhood and his home town of Vitebsk. In The Blue House (1917–20) [95] the absence of modelling makes the simple forms pile up almost like a child's cut-outs. In complete contrast, Window Overlooking the Garden [102] nevertheless retains the flatness of the earlier work: it is difficult

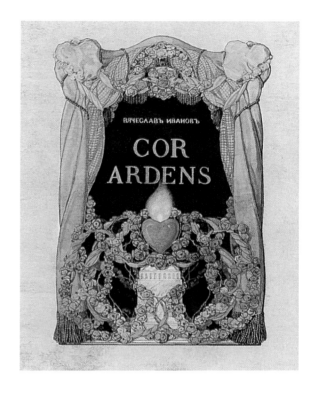

Above:
192- Konstantin Somov

Frontispice for Viacheslav Ivanov's book 'Cor Ardens', 1907 Watercolor, gouache, India ink, pen and brush. 28 x 20.2 cm Tretyakov Gallery, Moscow

191- Konstantin Somov

Firework Display, 1922 Oil on canvas. 27 x 31.5 cm Brodsky Memorial Museum, St. Petersburg

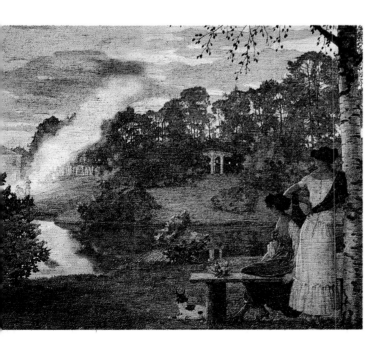

Following two pages:
95- Marc Chagall

The Blue House, 1917-1920 Oil on canvas. 66 x 97 cm Musée des Beaux Arts, Liège

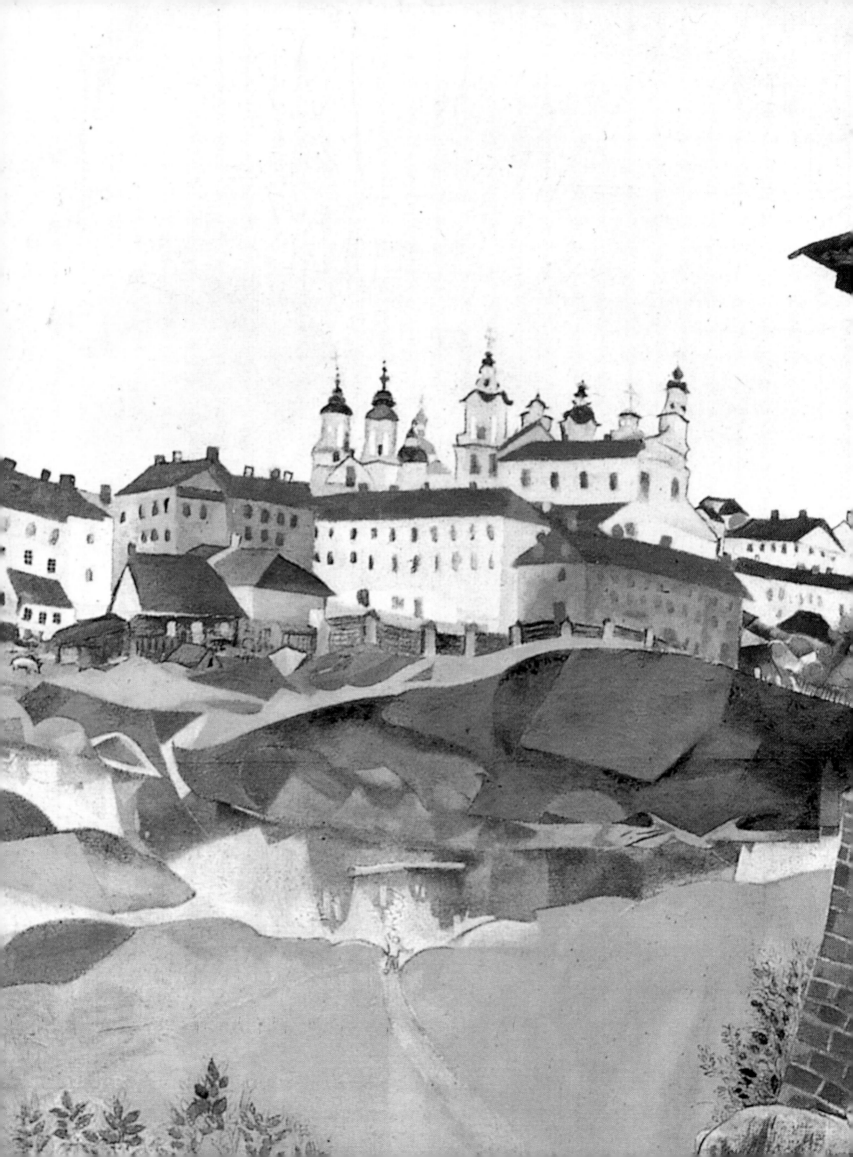

Preceeding two pages
102- Marc Chagall

*Window Overlooking the
Garden, 1917*
*Oil on paper mounted on
cardboard. 46.5 x 61 cm*
*Isaac Brodsky Memorial
Museum, St. Petersburg*

Left:
101- Marc Chagall

The Poet Reclining, 1915
Oil on cardboard.
77 x 77.5 cm
Tate Gallery, London

to believe that the garden beyond the window-frame is
not a scenery flat that can be picked up and carried off.
The most romantic of the three paintings here, The Poet
Reclining of 1915 [101], betrays Chagall's continuing
preoccupation with symbols, not all easily explained or
explicable. The trees and animals are again like something
executed by a child, there is an air of fairy-tale, as though
the quiet garden at sunset is about to become the scene of
mysterious happenings and the poet, by lying completely
still, will be allowed to witness them.

The classic Russian landscape of summer in the eyes
of most art-lovers is probably something like Alexei
Savrasov's A Country Road [42], sunset after a wet summer

42- Alexei Savrasov

A Country Road, 1873
Oil on canvas. 70 x 57 cm
Tretyakov Gallery, Moscow

81- Valentin Serov

Old Bath at Domotkanovo,
1888
Oil on canvas.
76.5 x 60.8 cm
Russian Museum,
St. Petersburg

day with the corn battered by the rain; Valentin Serov's intimate corner of a woodland in Old Bath at Domotkanovo [81]; or Lev Kamenev's Landscape with a River [51] painted in muted earth tones and greens. Isaac Levitan, whose work we looked at in the 'spring' section, also has a claim to be considered the foremost landscapist of the warm season (Little Bridge in the Village of Savinskaya [12]). His Birch Grove [121], in which the soft greens and yellows produce the tenderest effect, must rank high in the list of anyone's favourites. Another Birch Grove [44], by Arkhip Kuinji

51- Lev Kamenev

Landscape with a River, 1872
Oil on canvas.
59.5 x 50.5 cm
Russian Museum,
St. Peterburg

informs At the Academy's House in the Country (1898)
[80], but the air of utter tranquillity is no longer quite so
perfectly expressed – the busy picture with its focal point
on the left and its large expanse of grassy foreground is
more like a snapshot than a depiction of mood.[79]

Summer in a domestic setting is the theme chosen by
Sergei Sudeikin (In the Country [197]), Stanislav Zhukovsky
(The Terrace [180]) and Konstantin Somov (1869–1939).
Sudeikin (1882–1946) was, like Serebriakova, a member
of the World of Art group. His wonderful garden scene is
the essence of summer. Zhukovsky's terrace is bathed in
the light of evening – there is no blue left in the sky.
Somov produces a sweet-toned pastoral in Rainbow [192],
almost worthy of Marie Antoinette. Much more
interesting is Firework Display of 1922 [191], in which the

79- Ilya Repin

*Summer Landscape in Kurks
province, 1881
Study for the painting
Religious Procession in Kurks
Province, 1880-1883
Oil on card, 14 x 20 cm
Tretyakov Gallery, Moscow*

197- Sergei Sudeikin

In the Country
Private collection,
St. Petersburg

180- Stanislav Jukovski

The Terrace, 1906
Russian Museum,
St. Petersburg

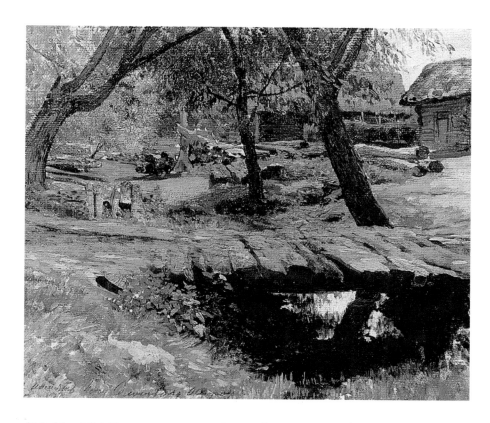

12- Isaac Levitan

Little bridge, Village of Savinskaya, Study, 1884
Oil on canvas. 25 x 29 cm
Tretyakov Gallery, Moscow

(1841–1910), was a sensation when it was first exhibited (1879). There was much speculation about the source of light – the public could not believe that it came from paint

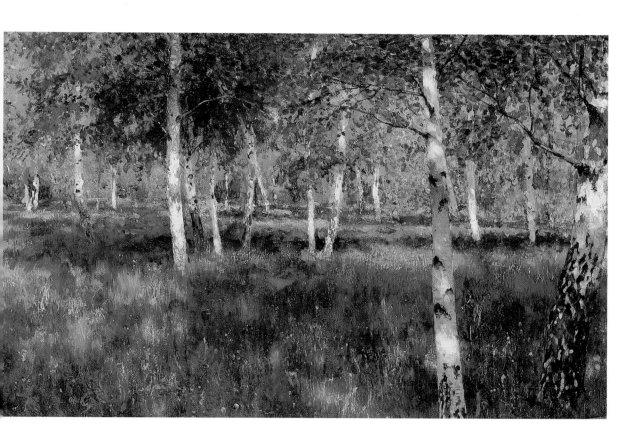

121- Isaac Levitan

Birch plantation, 1885-1889
Oil on paper mounted on canvas, 28.5 x 50 cm
Tretyakov Gallery, Moscow

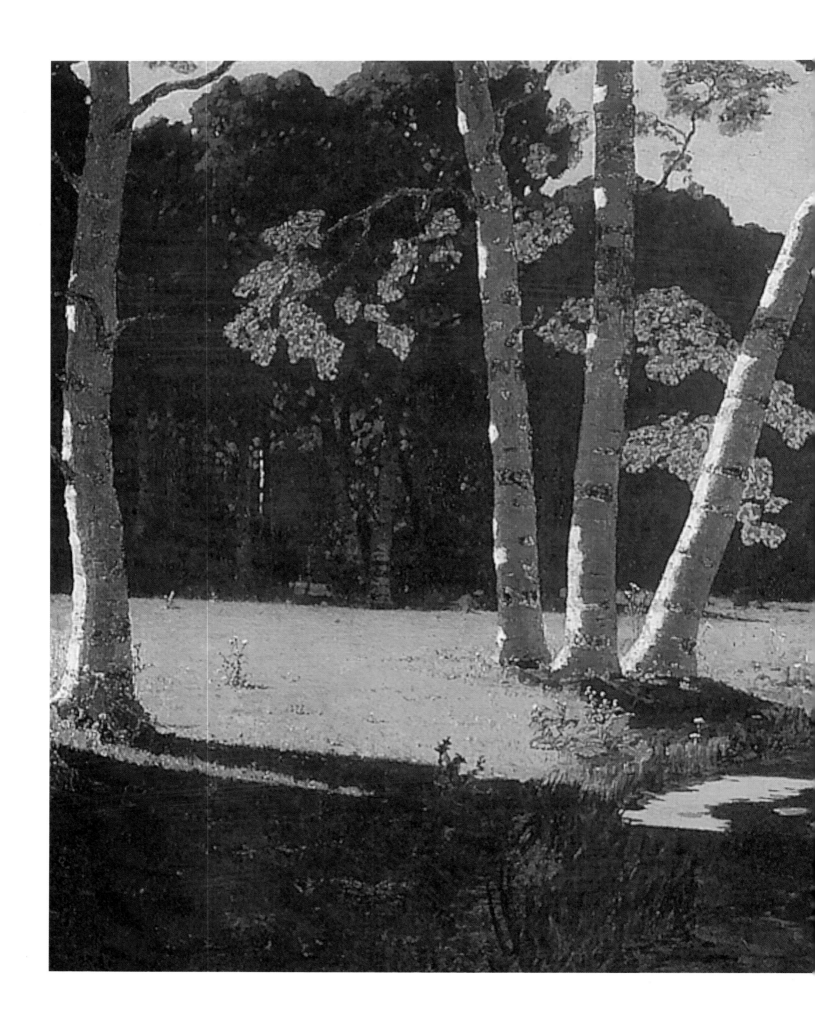

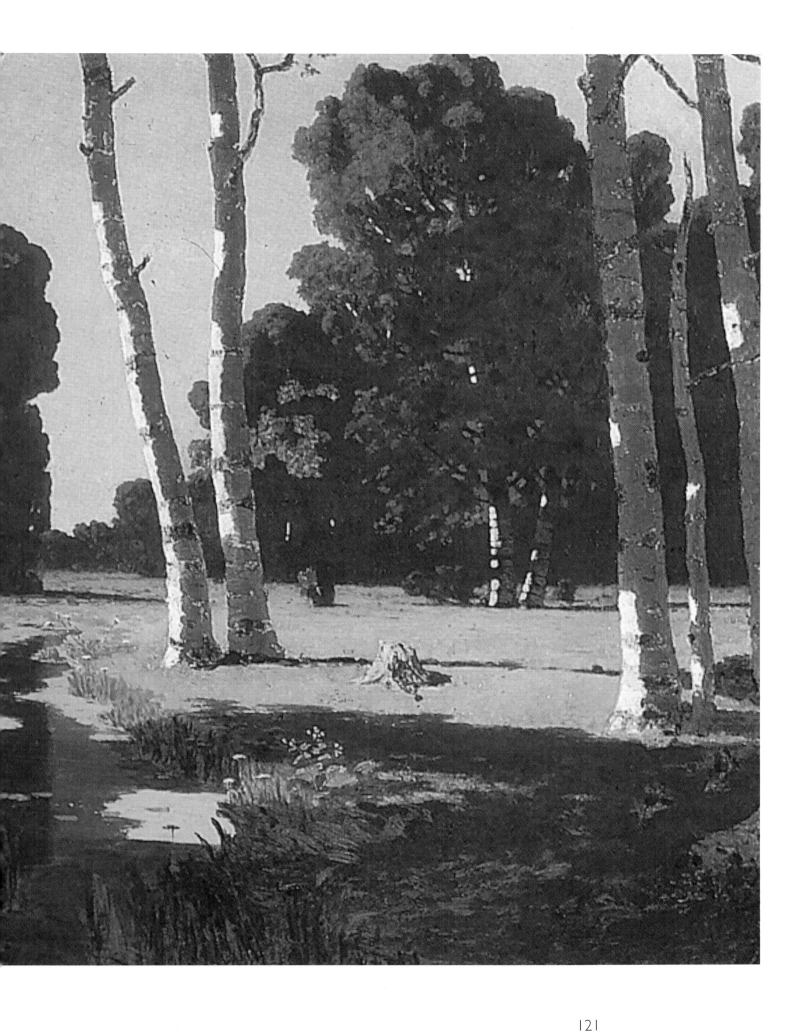

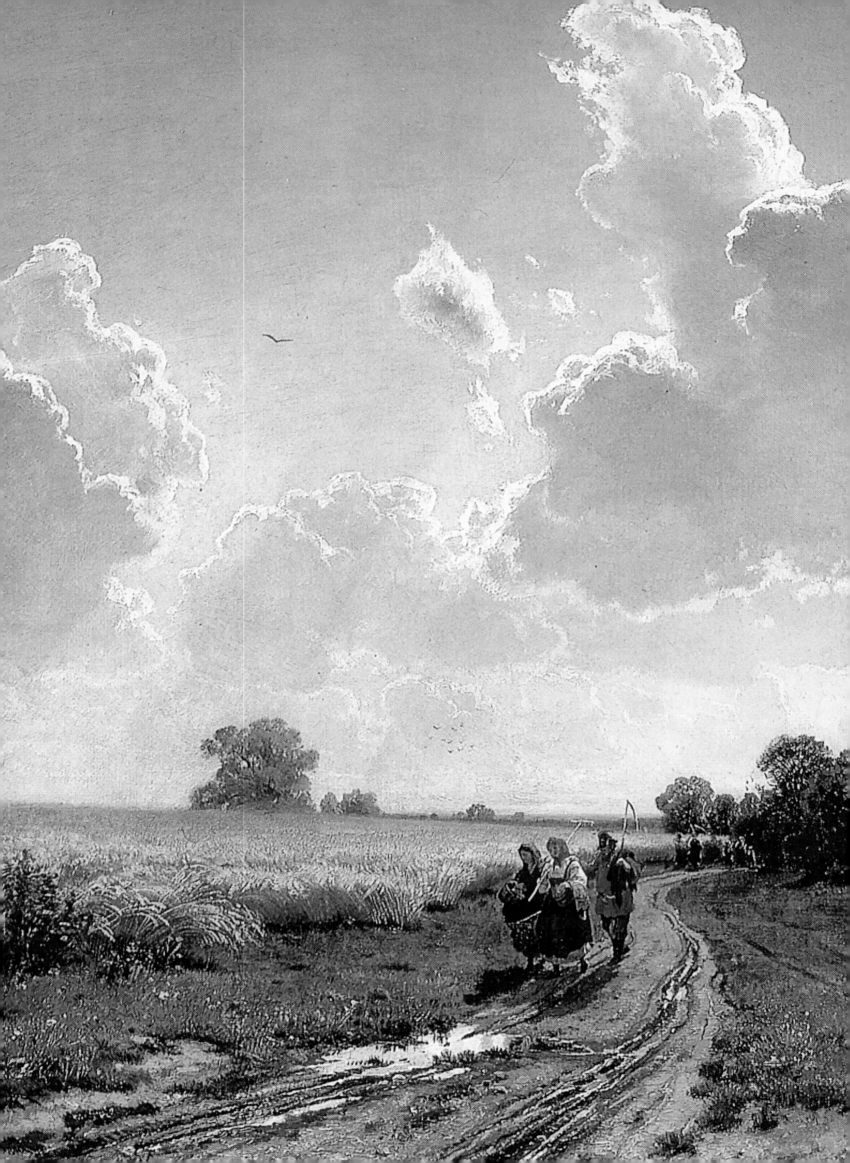

alone, and its luminosity is certainly striking.

When one thinks of summer landscapes, however, the artist that springs irresistibly to mind is Ivan Shishkin (1832–98). One of the most powerful and original painters of the 19th century, he was born in the Ukraine and studied in Moscow and St Petersburg, where he settled. He became an Itinerant in 1870, and taught several of the painters whose works feature in this book. He was passionately proud of being Russian, and early in his career resolved that the aim of his art would be to depict the countryside of his native land truthfully, without sentimentality or exaggeration. In this he surely succeeded, for he is without peer in his paintings of forest scenes, capturing in paint Tolstoy's word-pictures: 'The whole day had been hot. Somewhere a storm was gathering, but only a small cloud had scattered some rain-drops lightly, sprinkling the road and the sappy leaves. The left side of the forest was dark in the shade, the right side glittered in the sunlight, wet and shiny and scarcely swayed by the breeze. Everything was in blossom, the nightingales trilled, and their voices reverberated now near now far away' (War and Peace).

Shishkin had an innate bond with Nature, which he regarded as his greatest teacher, and understood the form of a tree as no one else did. His profound sympathy with the life of the peasants enabled him to immerse himself in their environment and develop a productive intimacy with it. His principles were shaped by the ideals of the new democratic realism in literature, which bore

Preceeding two pages:
44- Arkhip Kuinji

The Birch Grove, 1879
Oil on canvas. 997 x 181 cm
Tretyakov Gallery, Moscow

61- Ivan Shishkin

Midday in the Environs of Moscow, 1866
Oil on canvas. 65 x 59 cm
Kustodiev Picture Gallery, Astrakhan

123

fruit in his works of the 1860s. Midday in the Environs of Moscow. Bratsevo of 1866 [61], a sketch for the more famous picture of three years later, betrays the great attention to detail of Shishkin's early style, but in its great sweeping expanses of sky and cornfield there is a profoundly Russian sense of soul:

The sky was the grand neighbour

Of those hushed treetops,

And distance called to distance

In the long-drawn-out crowing of the cocks.

Pasternak, *August*

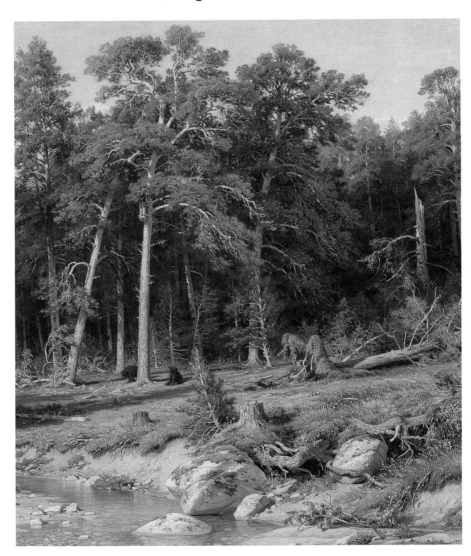

53- Ivan Shishkin
A Pine Forest. Mast-Timber
forest in Viatka Province,
1872
Oil on canvas. 117 x 165 cm
Tretyakov Gallery, Moscow

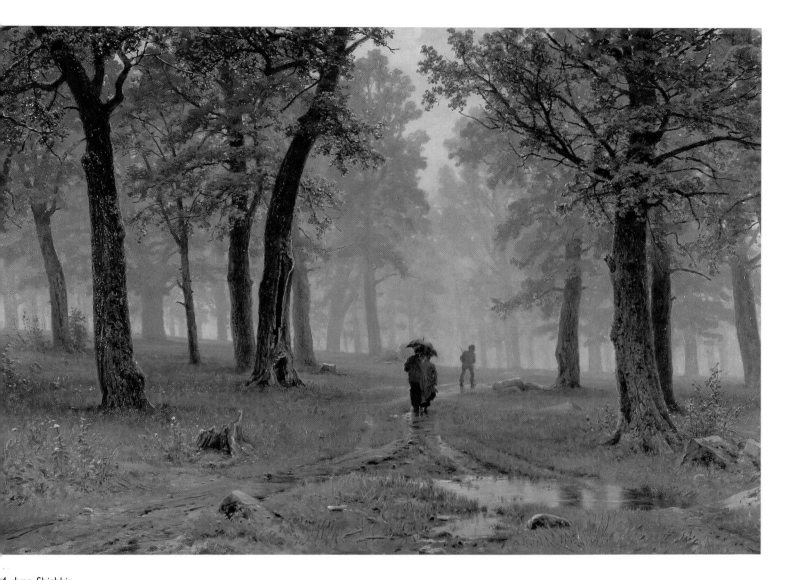

4- Ivan Shishkin

ain in an Oak Forest, 1891
il on canvas. 124 x 203 cm
etyakov Gallery, Moscow

Shishkin's approach to nature was to study it intently, sketching several studies a day before settling down to complete a painting. He would look at all the elements separately, then reconstruct them into an image of expressive power. His best paintings have an epic quality. A Pine Forest, Mast-Timber Forest in Viatka Province of 1872 [53] is a work of tremendous impact; it radiates a vigorous life-force, the trees individualized, the shallow stream flowing sweetly, the peaceful atmosphere enlivened by the bears working out how to reach the beehive. An exquisitely beautiful study is Rain in an Oak Forest [54], a most successful rendering of texture and atmosphere. The

Following pages:
52- Ivan Shishkin

"Amidst the Spreading Vale...",
1883
Oil on canvas.
136.5 x 203.5 cm
Museum of Russian Art, Kiev

70- Ivan Shishkin

The Shore of the Gulf of
Finland (Udrias near Narva),
1889
Oil on canvas.
91.5 x 145.5 cm
Russian Museum,
St. Petersburg

sodden woodland appears to shimmer in a silver-green mist and we can almost hear the squelching of boots as the walkers make their way along the muddy path.

Shishkin did not confine himself to forest landscapes alone. In Amidst the Spreading Vale ... of 1883 [52] he glories in huge sweeps of space, the sturdy oak virtually the only feature in an endless expanse. Shishkin himself noted that productive farmland was a gift from God and provided 'Russian riches'. The Shore of the Gulf of Finland [70] shows us that he was equally adept at seascapes, conveying the sensation of a warm hazy day with the sea lying calm below. His last major work was Mast-Tree Grove [56], painted shortly before his death. It shows him at the top of his powers: a perfect rendering of the magnificent pines, a harmonious colour balance, a precise attention to detail result in a classically complete yet warmly inviting woodland scene.

In a complete departure from the deep forests and wide cornfields of northern and central Russia, let us turn to the work of the great Armenian painter Martiros Saryan and his near-contemporary Pavel Kuznetsov (1878–1968), whose ethereal vision of yurts in Kibitkas

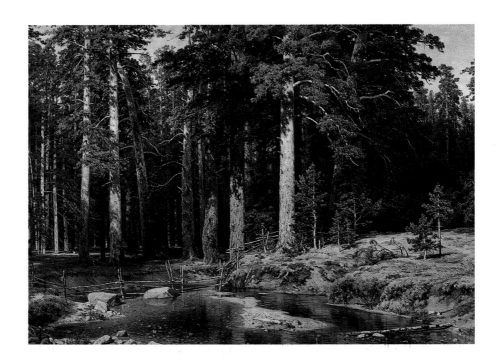

56- Ivan Shishkin

Mast-Tree Grove, 1898
Oil on canvas. 165 x 252 cm
Russian Museum,
St. Petersburg

[193] is like a mirage, that phenomenon of the desert. We have already seen some of Saryan's spring pictures, and the southern summer is even more truly exotic.

Saryan's colour sense, his sense of form, even his subject-matter, are immediately traceable to the influence of Gauguin and Matisse, but he brings to all his vast and varied output an exciting creativity quite unlike any other artist's. In his journeys to the southern and oriental regions of the Russian Empire, he was entranced by the heat, the relentless sunshine, the veiled women, the nomads with their animal herds. Like Shishkin he felt that Nature was his greatest teacher, and he drank in the colours and shapes of the south. In the Caucasus, Tiflis [137] is a cityscape that breathes the heat of the buildings and streets; the startling deep blue of the shadows seems absolutely right. The same colour scheme is employed to dazzling effect in Mount Abul with Passing Camels [141], the subject of which is without doubt the mountain – the camels are there purely to provide perspective. A cityscape in a more 'realistic' tonal range is Yerevan [127].

The colour palette has widened by 1923, when Saryan produced Sunlit Landscape [143]. This is a dramatic example of his

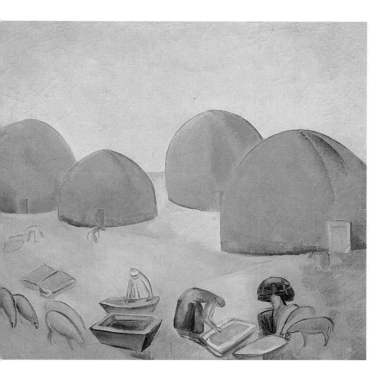

93- Pavel Kuznetsov

Kibitkas, second half of the 910s
Oil on canvas. 95 x 95 cm
Kustodiev Picture Gallery, Astrakhan

137- Martiros Saryan

In the Caucasus. Tiflis, 1907
Tempera on canvas.
34 x 48 cm
K. Saryan collection, Yerevan

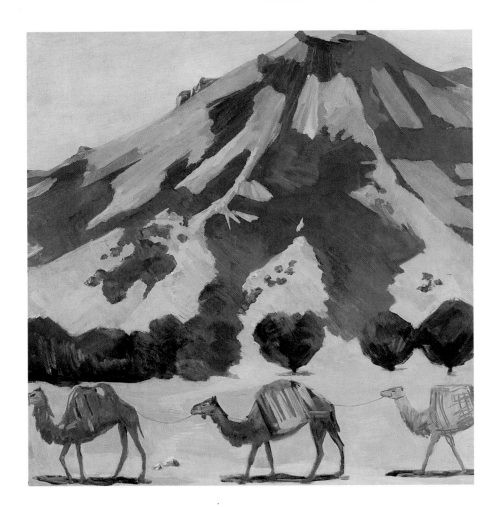

141- Martiros Saryan

*Mount Abul with Passing
Camels, 1912*
Oil on canvas. 138 x 142 cm
*National Gallery of Armenia,
Yerevan*

landscape formula, with its hot colours, dynamic shapes
and seemingly limitless spatial compass. The colours are
so rich and bold that they make the viewer blink, but they
sing of the majestic sweep of the eternal mountains which
dwarf all human existence. A softer palette prevailed
towards the end of the artist's life. Bzhni, The Fortress [150]
shows the ancient ruin on the mountain-top looking as if
it had grown there, so naturally does it fit into the
scenery. The tall tree blowing in the breeze, seeming to
stretch up towards the
fortress, is a masterstroke
from this wonderfully
exciting painter, who
epitomizes the soul of his
country in a way that is
every bit as valid as that
of his northern
counterparts, and
provides a piquant
contrast to it.

127- Martiros Saryan

Yerevan, 1924
Oil on canvas. 69 x 68 cm

132

143- Martiros Saryan

Sunlit Landscape, 1923
Tempera on canvas.
70 x 78 cm
National Gallery of Armenia,
Yerevan

150- Martiros Saryan

Bzhni, The Fortress, 1946
Oil on canvas. 82 x 60 cm
Martiros Saryan Museum,
Yerevan

Mist and Gold

October comes at last. The grove is shaking

The last reluctant leaves from naked boughs.

The autumn cold has breathed, the road is freezing –

The brook still sounds behind the miller's house,

But the pond's hushed; now with his pack my neighbour

Makes for the distant field – his hounds will rouse

The woods with barking, and his horse's feet

Will trample cruelly the winter wheat.

Pushkin, *Autumn*

There is an ineluctable sadness about autumn. Though it has its own seasonal beauties, it nevertheless signals the end of the mild weather for another year, the coming of the dark days. The Russian characteristic of melancholy comes into its fullest expression in September and October. Golden days and crisp mornings are not enough to keep it at bay, even when a brisk horseback ride through the bare fields can be

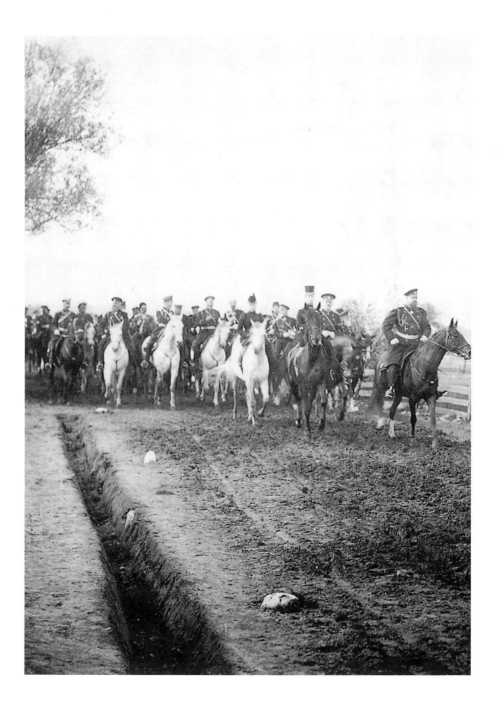

157- Alexander III and Maria Fedorovna on Military Exercises

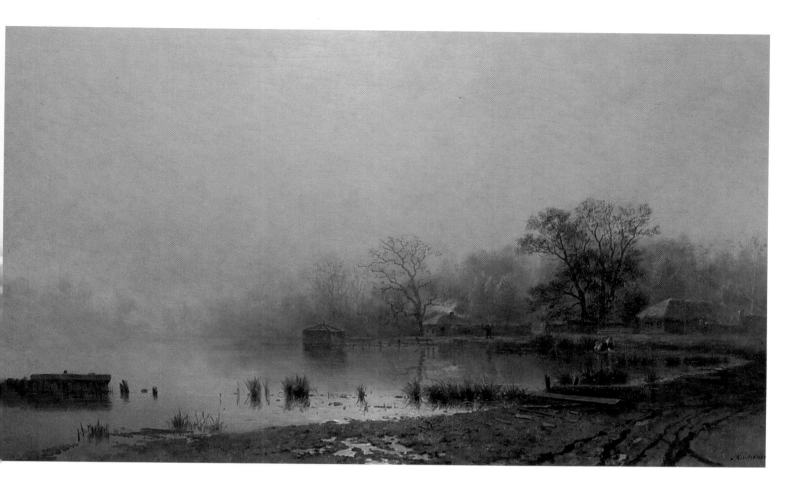

undertaken as an antidote [157].

Perhaps even more than summer, autumn is the season most difficult to define in terms of the city. One of the most successful attempts is Lev Kamenev's magical Fog, The Red Pond in Moscow in Autumn (1871) [200]. The sun is there somewhere, above the mist, but is completely hidden – we know only because of the light reflected from the water. Apart from this patch of light the palette is almost monochrome, and tremendously effective.

Dostoyevsky discerned a love of humanity in the works of Vladimir Makovsky, the jovial genre painter whose work we have already touched on. Makovsky attained his peak in works that can be termed 'novellas', such as On the Boulevard [30]. Here he conveys the drama of a difficult human situation, the tense reunion between a young husband, who has left his village for the city in order to improve his material circumstances, and the wife,

200- Lev Kamenev

Fog. The Red Pond in Moscow in Autumn, 1871
Oil on canvas. 68 x 113 cm
Tretyakov Gallery, Moscow

little more than a girl, who finds a stranger in place of the man she married. The misery on the girl's face is eloquent; the young man is unaware of it. The falling leaves and chilly grey background only add to the girl's despair.

Mstislav Dobuzhinsky (1875–1957), a member of the World of Art association, selected watercolour for a more cheerful aspect of autumn, his delightful portrayal of an old town: Vilno (now Vilnius, Lithuania) [199]. This is surely the stuff of fairy-tale, or at least its embodiment on

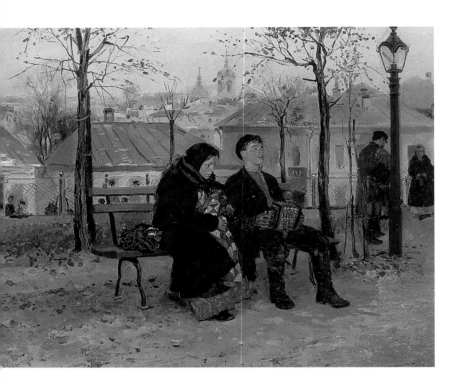

30- Vladimir Makovsky

On the Boulevard, 1886-1887
Oil on canvas. 53 x 68 cm
Tretyakov Gallery, Moscow

Below:
199- Mstislav Dobuzhinsky

Vilno, 1910
Watercolor and tempora on paper mounted on carboard
51.5 x 68 cm
Private collection,
St. Petersburg

138

stage: the viewer would not be surprised to see a talking horse, a swan-maiden or a demon wolf glide round the corner and begin to perform.

Religion is a constant factor: its observance is deeply embedded in the Russian character. Every household used to have an icon, a holy image which presided over every

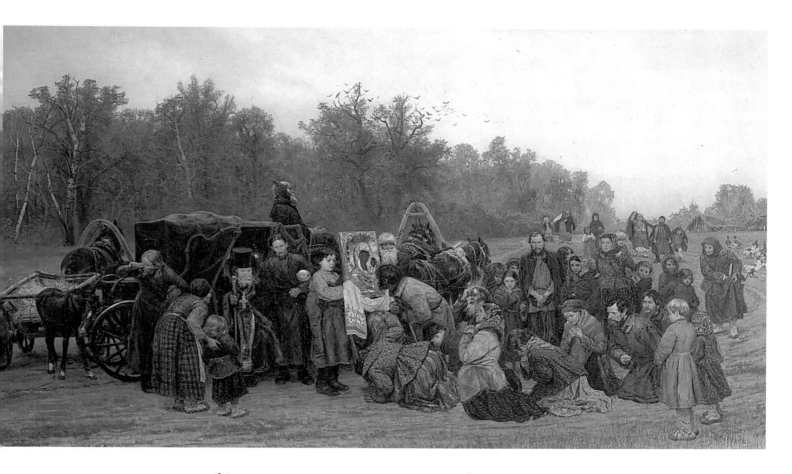

event of importance, major or minor. When it travelled, everyone in its path hastened to honour it. Konstantin Savitsky (1844–1905), an Itinerant who liked to depict peasant life, shows us such a scene in Meeting the Icon [28], the peasants devoutly praying in the gloomy autumn landscape. The tones are subtle, the trees softened and greyed by distance.

Ivan Shishkin's genius flourished in his favoured métier of summer landscapes, but he produced many masterpieces of autumn as well. As a student he spent several months at a time painting and sketching on Valaam Island in Lake Ladoga, and in 1867 painted

28- Konstantin Savitsky

Meeting the Icon, 1878
Oil on canvas. 141 x 228 cm
Tretyakov Gallery, Moscow

139

Landscape with a Hunter, Valaam Island[58]. His eye for detail was already notable; indeed, at this early stage it sometimes threatened to upset the balance of the

composition, but here the distant figure of the hunter draws us irresistibly into the golden woodland. Shishkin, as we have already seen, liked to make numerous sketches en plein air in both pen and oils, and the charming little study of Fly-Agarics[63] is an autumnal subject if ever there was one. But perhaps it is not by chance that he chose this particular genus. The pagan shamans of ancient Rus traditionally

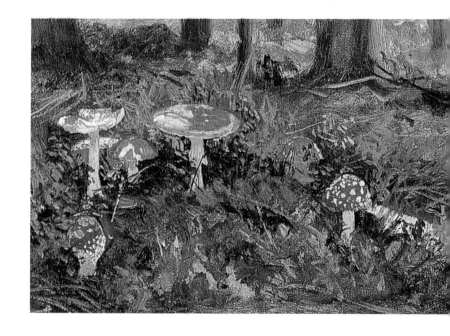

used a constituent of fly-agaric to induce trances and visions, and Shishkin must surely have known the folklore of his beloved Russia.

Shishkin's love of great open spaces and limitless skies finds expression in Landscape in Polesye [66], a September scene in Belorussia. Morning in a Pine Forest [71] is a well-loved work showing the forest at daybreak as the early sun dissipates the autumn mist. The popularity of the picture doubtless derives to some extent from its central feature, the family of bears – the national animal of Russia – at play or foraging in the woodland. The animals' fur and dangerously sharp claws are beautifully rendered. The poetic quality of the painting is such that we are sure we can hear the crackle of twigs as the mother bear shifts her weight.

Work on the land must continue, and as autumn draws on the need to finish becomes more urgent. But there is still time to stop and watch the flight of migrating birds as they leave for a warmer climate. Alexei Stepanov (1858–1923) painted Cranes are Flying [37]

6- Ivan Shishkin

andscape in Polesye, 1884
il on canvas.
1.5 x 117.5 cm
rt Museum of Bielorussia,
1insk

71- Ivan Shishkin

Morning in a Pine Forest,
1889
Oil on canvas. 138 x 213 cm
Tretyakov Gallery, Moscow

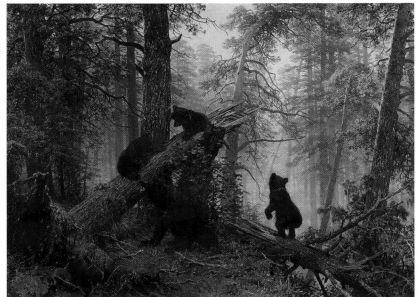

141

in 1891, with its endless vista over the marshes. Hunters, too, have to busy themselves at this time of year. Vasily Perov (1834–82) depicted in Hunters at Rest [25] the ordinary people of Russia going about their business, at

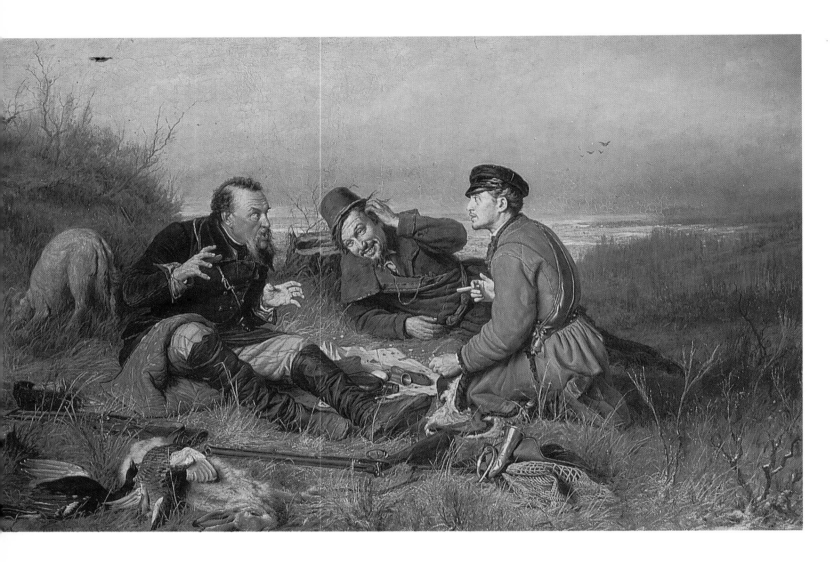

25- Vasily Perov

Hunters at Rest, 1871
Oil on canvas. 119 x 183 cm
Tretyakov Gallery, Moscow

ease with the natural world around them. The three men are sharply but affectionately characterized, chattering animatedly against the darkening evening sky, their day's bag lying at their feet.

Ploughing is an essential autumn task. The wide skies and rolling plain of the central region, which have their counterpart in the generous character of the Russian people, form the background of In the Ploughed Field [43] by Mikhail Klodt (1865–1918). Klodt, with Savrasov and Shishkin, was one of the first exponents of the Russian

national landscape. The artists of the later World of Art group sought to transform the commonplace by revealing the lyrical qualities of the most ordinary features of the countryside. The subject of Konstantin Somov's

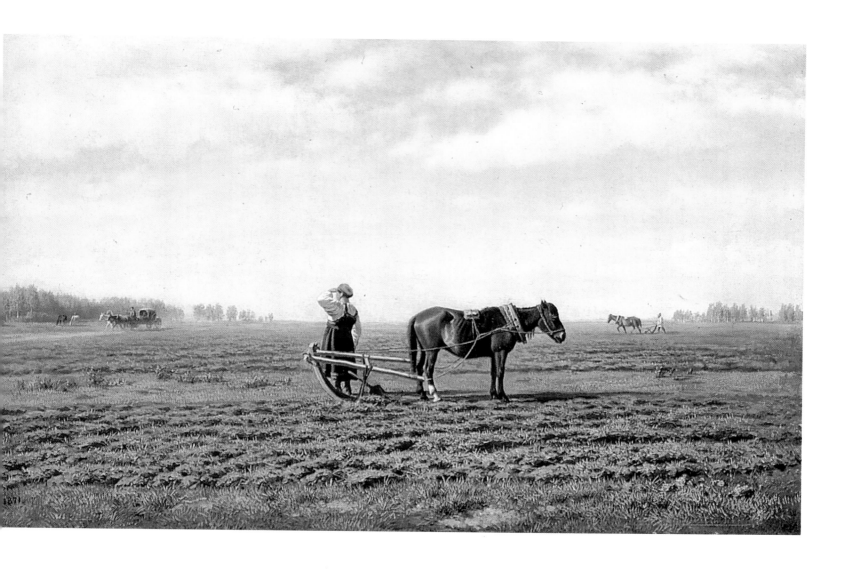

Above:
3- Mikhail Klodt

n the Ploughed Field, 1871
il on canvas.
7.5 x 81.5 cm
ussian Museum,
t. Petersburg

94- Konstantin Somov

oughland, 1900
il on carboard. 31 x 73 cm
adishchev Art Museum,
aratov

Ploughland [194] has nothing unusual about it, but the strong shapes and warm tones give the picture a certain poetry. Compare it with Martiros Saryan's treatment of the same theme in Ploughing [146], where the dramatic

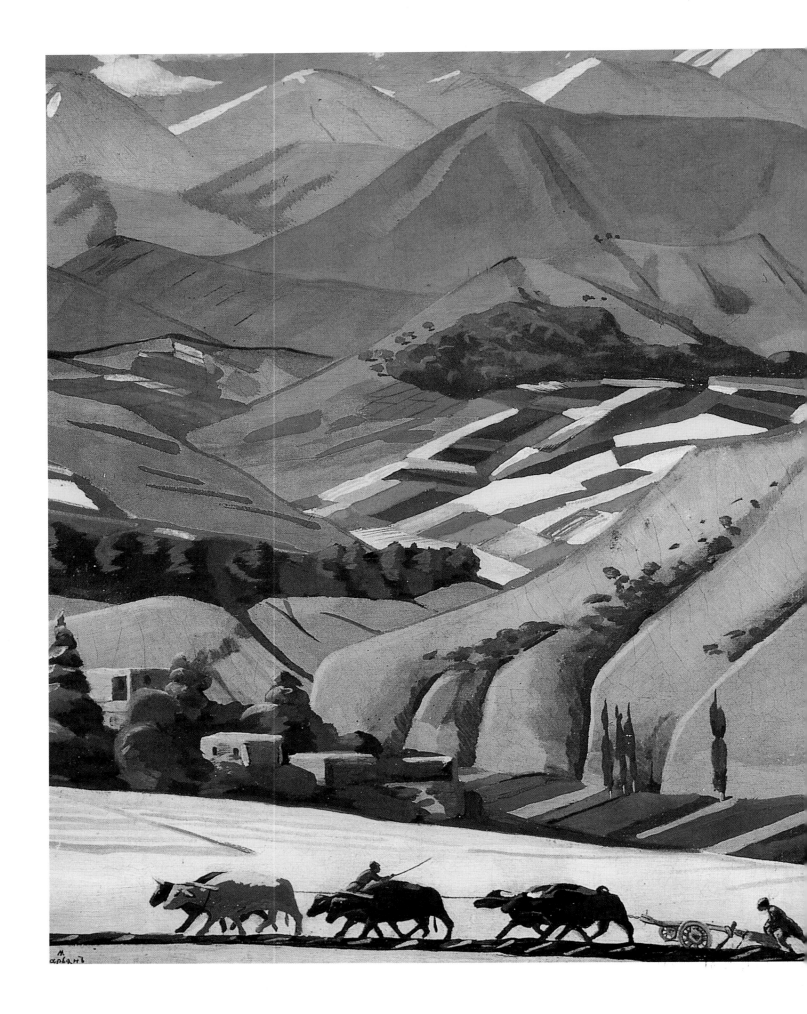

Armenian landscape and vivid coloration could not be more diametrically opposed.

The genius of Ilya Repin was brought to bear on his portraits of his friend and mentor Leo Tolstoy, done over a period of thirty years. A side of Tolstoy that appealed particularly to the painter was his life as an 'aristocratic peasant', the pursuit of which fuelled the public

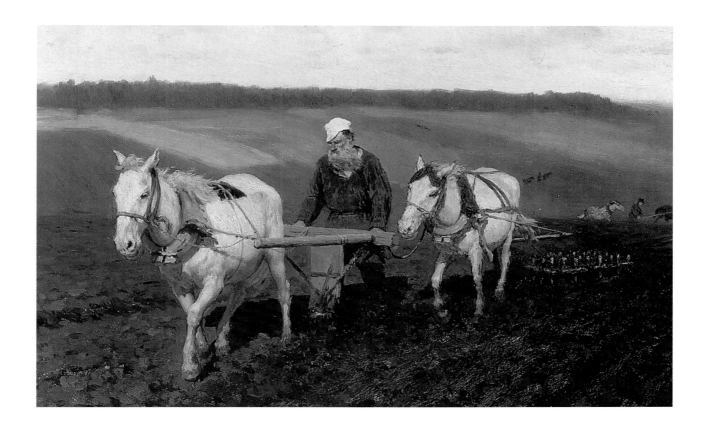

perception of him as a living legend. Repin was able to show him in the flesh, as it were, pinning down this remarkable character as he stomped across his acreage with his horses. A Ploughman, Leo Tolstoy Ploughing (1887) [159] is really a portrait, but it shows why Tolstoy was so attached to his land: he is almost part of the rich black earth he loved. The writer himself stated: '...It is forgotten that nourishment by corn, vegetables, and fruit, raised from the soil by one's own labour, is the pleasantest, healthiest, easiest, and most natural nourishment, and that the work of using one's muscles is as necessary a

159- Ilya Repin

A Ploughman, Leo Tolstoy Ploughing, 1887
Oil on cardboard
27.8 x 40.3 cm
Tretyakov Gallery, Moscow

146- Martiros Saryan

Ploughing, 1929
Illustration to the Anthology of Armenian Folk-Tales
Indian ink on paper.
17 x 12 cm
Martiros Saryan Museum, Yerevan

condition of life as is the oxidization of the blood by breathing' (from 'What is Art?').

That other great master of the Itinerants' national landscape school, Isaac Levitan, had much to say about

autumn. The golden colours, the crisp days, the melancholy of the season were all perfectly in tune with his artistic goal: to reveal the distinctive character of the Russian landscape. A pastel sketch of Autumn [170] catches the melancholy mood exactly. In his well-known Autumn Day at Sokolniki [8], the melancholy is more personalized – the sad demeanour of the slender figure as she walks quickly, with bowed head, is echoed in the blustery, overcast day. Is she gloomy because summer is over, or does her unhappiness have an unrelated cause? In this very early work (1879) Levitan projects her mood on to her surroundings in a masterly example of the so-called 'pathetic fallacy', the idea that Nature is in tune with our human emotions.

From this point on Levitan was tireless in his search for new motifs and moods which would show Russian

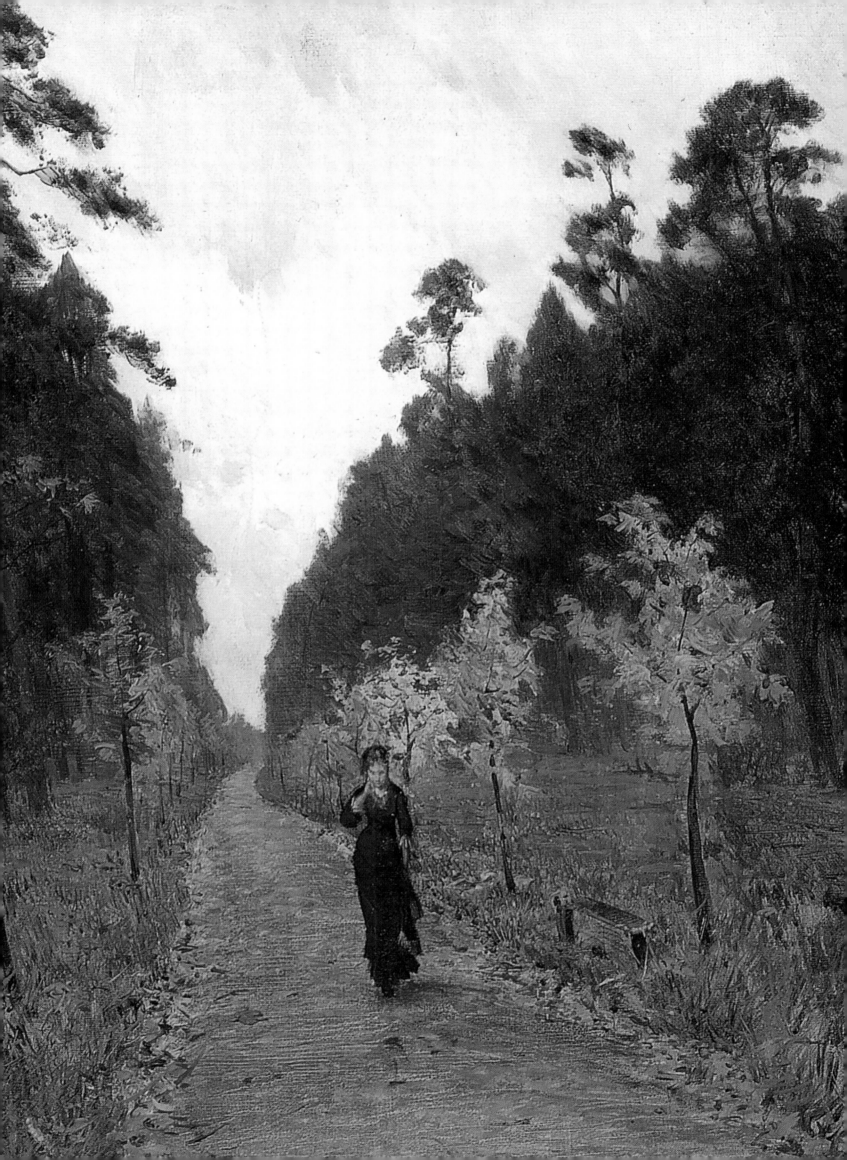

9- Isaac Levitan

Mill and Village near a Stream, early 1880s Oil on canvas. 19.7 x 33.3 cm Russian Museum, St. Petersburg

nature in all its glory. A sun-kissed autumn scene of a few years later is Haystacks – Village on a River [9], in which all thought of melancholy is banned: the tiny hamlet seems perfectly self-sufficient, the corn is already cut and stacked. Golden Autumn: in the Village [14], painted in 1889, is a much more Impressionistic treatment of a similar theme.

Levitan did not flinch from expressing the dark side of the Russian psyche in his landscapes. One of the most powerfully affecting is The Vladimirka Road of 1892 [16], winding for mile after mile across desolate, featureless

14- Isaac Levitan

Golden Autumn, in the Village,
1889
Oil on canvas. 43 x 67.2 cm
Russian Museum,
St. Petersburg

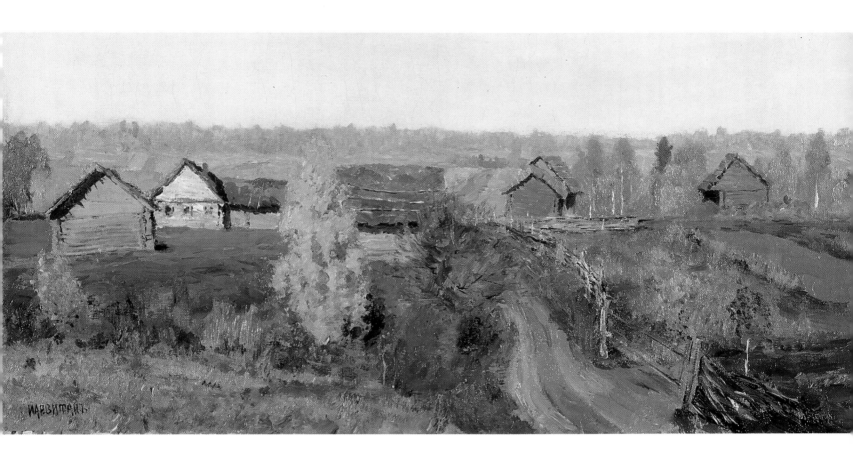

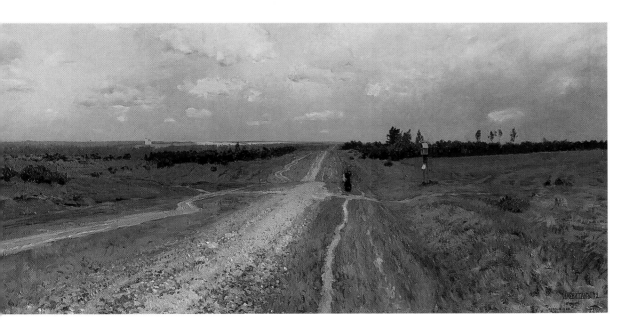

16- Isaac Levitan

The Vladimirka Road, 1892
Oil on canvas. 79 x 123 cm
Tretyakov Gallery, Moscow

18- Isaac Levitan

Stormy day, 1897
Oil on canvas. 82 x 86.5 cm
Tretyakov Gallery, Moscow

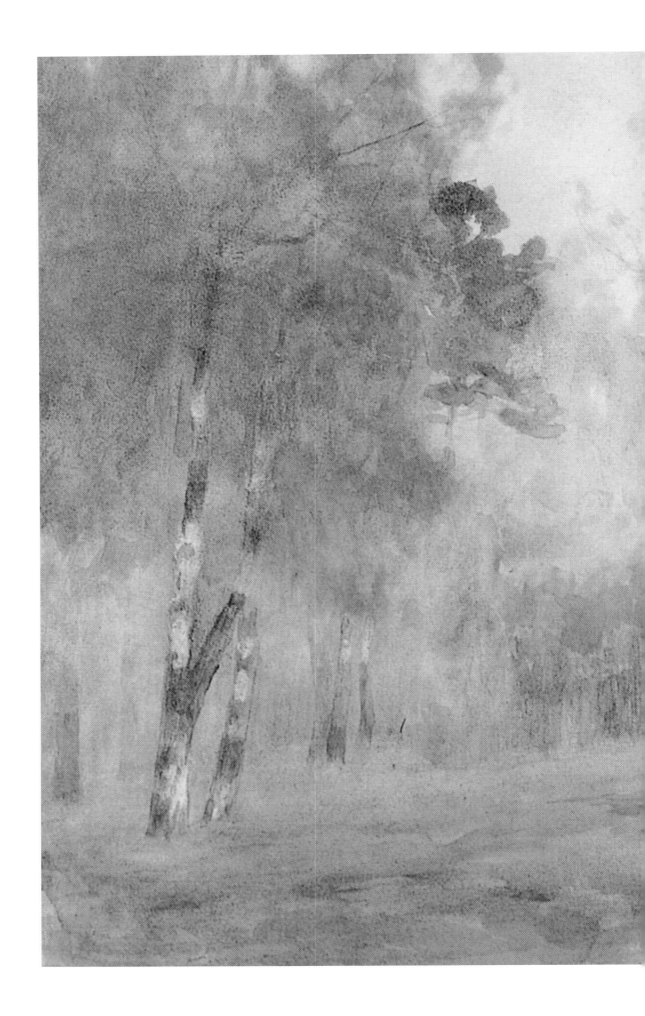

176- Isaac Levitan

Mist, Autumn, 1899
Watercolour and white on
paper. 48 x 60 cm
Russian Museum,
St. Petersburg

plains. This was the road taken by prisoners exiled to Siberia, who had to walk the whole way in chains. The church visible in the far distance is an ironic touch; there is no help from God for the poor creatures condemned to an existence of misery. It is almost a relief to turn to Stormy Day [18], where the outcome of the storm is likely to be the loss of those crops as yet unharvested – a misfortune, but hardly the human tragedy of the Vladimirka road and its goal, Dostoyevsky's 'House of the Dead'.

152- Martiros Saryan

October in Yerevan, 1961
Oil on canvas. 79 x 102 cm
Museum of Oriental Art,
Moscow

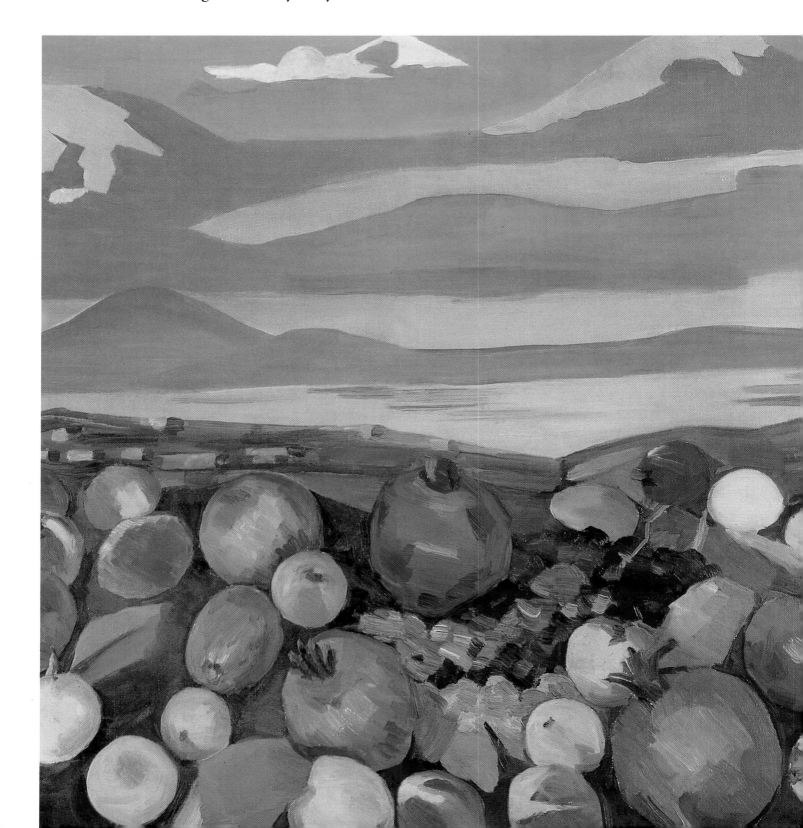

Our last example here of Levitan's extraordinary range is a wonderful watercolour sketch of Mist. Autumn [176], done in 1899. This is a tour de force, a world of magic in which the delicacy of the tonal range, the precise rendering of the imprecise, the sheer lyricism, are all quite breathtaking.

Autumn in the south is in the strongest possible contrast. October in Yerevan [152] is one of Martiros Saryan's most brilliantly colourful compositions, painted in 1961 towards the end of his career. The ripe abundance of the fruit against the backdrop of the mountains in sharp sunshine and shadow is an offering of thanksgiving for the riches that Nature has bestowed. The Surb-Khach Rocks at Kalaki [142], painted in 1914, displays a spatial

142- Martiros Saryan

The Surb-Khach Rocks at Kalaki, 1914
Oil on canvas pasted on cardboard. 36 x 47.5 cm
Art Museum, Yaroslavl

157

grandeur and magnificence, executed in the hot colour range that he loved all his life. By 1928 he shows, with Hazy Autumn Day [147], that he is capable of restraint, but it is his colours that we respond to so unhesitatingly – great shouts of joy that lift the soul of his native Armenia.

Valentin Serov is known above all for his splendid portraiture, but he is a painter of such gifts that his essays in landscape are utterly convincing. Little Pond: Abramtsevo of 1886 [105] treats the same kind of subject as

147- Martiros Saryan

Hazy Autumn Day, 1928
Oil on canvas. 59 x 73 cm
Martiros Saryan Museum,
Yerevan

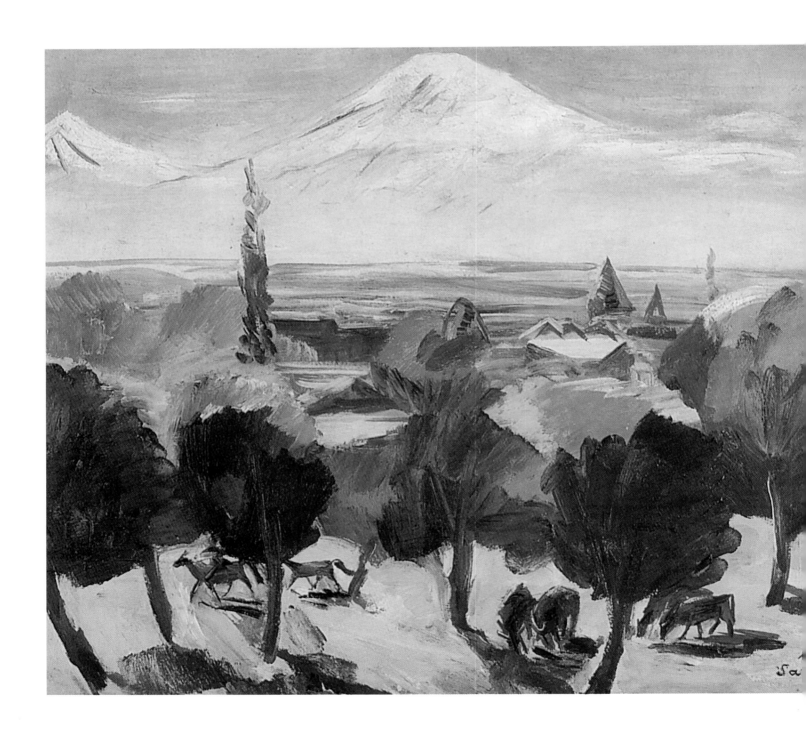

many of Shishkin's woodland scenes, but from an Impressionist viewpoint. From the 1880s he concentrated more on the genre as he became attracted to the subject of peasant life on the land. A rural scene of an everyday kind vibrates with love for the autumn landscape (October in

159

107- Valentin Serov

October in Domotkanovo,
1895
Oil on canvas.
48.5 x 70.7 cm
Tretyakov Gallery, Moscow

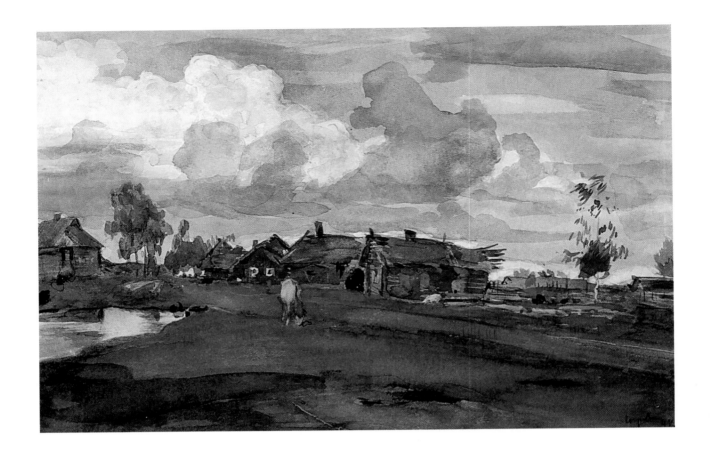

108- Valentin Serov

A Village, 1898
Gouache and watercolour on
paper mounted on
cardboard. 25.5 x 37.5 cm
Tretyakov Gallery, Moscow

89- Igor Grabar

September Snow, 1903
Tretyakov Gallery, Moscow

Domotkanovo, 1895 [107]), while A Village (1898) [108] shows us the artist completely in sympathy with the harsh life that goes on in the drab, tumbledown houses.

The minor but interesting artists Igor Grabar (1871–1960) and Stanislav Zhukovsky exemplify the later tendency of the Russian Impressionist movement towards

the decorative. Grabar's September Snow of 1903 [89] with its thick blobs of paint produces an effect that is very nearly tachiste. No one wants to see snow so early in the year, but the woman carrying milk-churns has a determined stride that seems to say, in a very Russian way, 'Let's make the best of it'. Jukovsky's autumn is kinder. His riverscape in Autumn [179] still has some warm sunshine in it – the blue of the river is not the icy blue of winter as yet. The heavy brush-strokes of Road in Autumn [85] allow

179- Stanislav Jukovski

Autumn
Tretyakov Gallery, Moscow

163

the golden-leaved trees to draw the gaze, rather than the road winding away uphill. Vera Yermolayeva (1893–1938) portrays a peasant woman with her child as the very essence of the Russian land [128]. The woman is dressed in autumnal brown and carries a rake; she represents a kind of solid earth-spirit, at a time (1933) when such

128- Vera Ermolayeva

Peasant Woman with Rake and Child, 1933
Gouache on paper.
29.5 x 22 cm

imaginings were not encouraged.

Soaring away into another dimension, Vasily Kandinsky takes us into the realms of the abstract (Composition. Landscape, 1915 [134]). But although he has broken away from the representational world of objects, this work retains a strong feeling of life, of a dynamism that is part of the natural world. The glowing colours, the organic forms that the eye perceives if it does not try too hard, the impression that the whole composition is encircled by the warmth of the harvest sun – all these provide a fitting climax to our search for the spirit of autumn.

134- Vasily Kandinsky

Composition, Landscape, 1915
Watercolor, indian ink and white on paper
Russian Museum, St. Petersburg

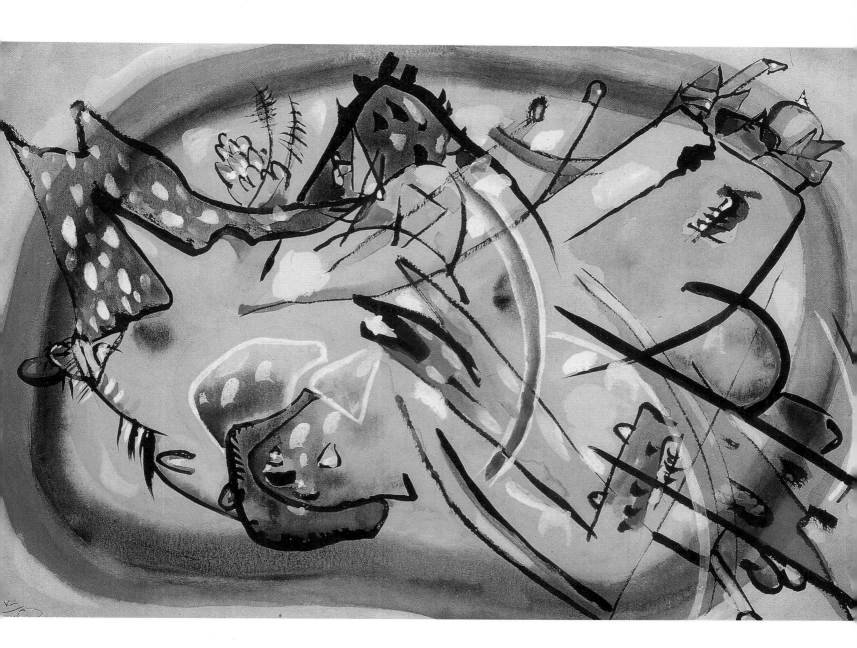

Grandfather Frost

Winter is the season that, Russians feel, belongs especially to them.

In Pushkin's long poem Eugene Onegin, Tatyana, the heroine...

Was yet a thorough Russian; hence
She loved the Russian winter season
And its cold white magnificence.

06- Valentin Serov

Winter in Abramtsevo -
A House, 1886
Oil on panel. 37 x 29 cm
P. N. Krylov collection,
Moscow

Northern winters have given rise to many folktales and legends, such as the story of Grandfather Frost, Bonny Spring and their daughter the Snow Maiden, who must not be touched

73- Ivan Shishkin

"A pine there stands in the northern wilds..."
Based on Mikhail
Lermontov's verse The Pine,
1891
Oil on canvas. 161 x 118 cm
Museum of Russian Art, Kiev

168

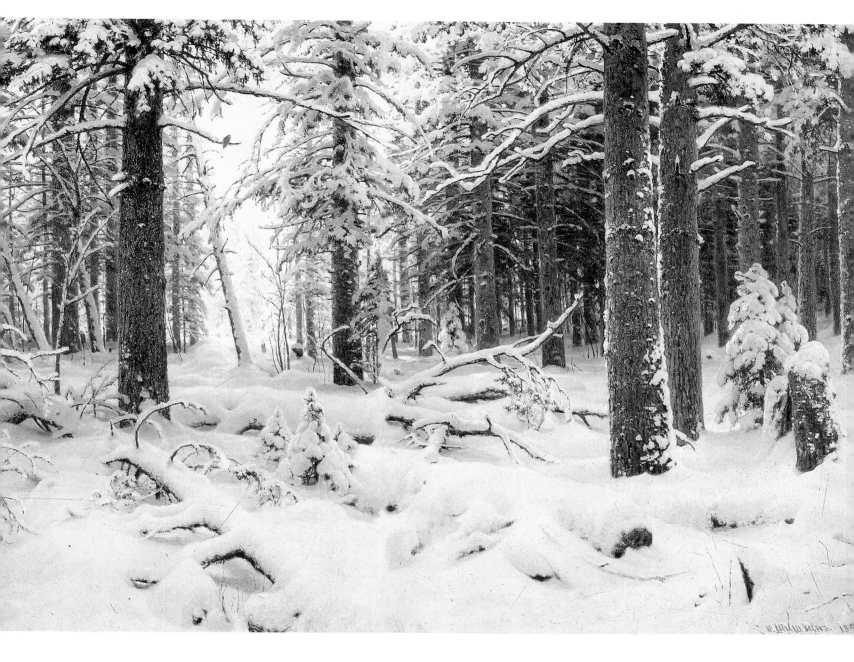

with warmth lest she melt away. Many composers have been inspired by such tales. Rimsky-Korsakov wrote an opera based on the Snow Maiden legend; Tchaikovsky's 'Sugar Plum Fairy in The Nutcracker' is a kind of ice princess and her music chimes and shimmers like the frozen surface of a lake.

This personification of Nature is very Russian, and the great landscapists have invested their paintings of winter with its spirit. The tree gracefully drooping under its heavy drapery of snow in Shishkin's A Pine There Stands in the Northern Wilds ... [73] is an animate being,

72- Ivan Shishkin

Winter, 1890
Oil on canvas.
125.5 x 204 cm
Russian Museum,
St. Petersburg

Following pages:
7- Isaac Levitan

Park under Snow, 1880s
Gouache and watercolour on
paper mounted on cardboard.
29.2 x 35.1 cm
Russian Museum,
St. Petersburg

ready to spread its branches and dance in the moonlight. The still, silent woodland in Winter [72] is pulsating with possibly malevolent spirits which the traveller is aware of but cannot quite see. Isaac Levitan's winter scenes are less wild. His gentle woodland Garden in the Snow [7] is friendly and domesticated, and he has chosen to depict it in sunshine with a sky of that cold duck-egg blue typical of crisp winter days. His Village, Winter [175] is cosy on a dull, overcast day, the little houses almost up to their waists in snow and only one brave soul venturing out into the cold. In a very different vein, Igor Grabar treats the woodland of February Sky [88] purely decoratively – the branches, trunks and dead leaves

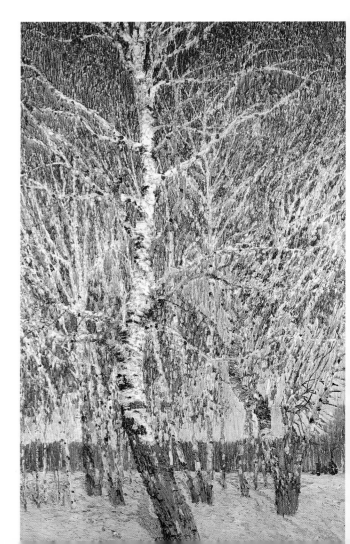

172

form an abstract pattern against the blue.

The strong tradition of historical and genre painting which developed from about the 1820s produced some magnificent works in the middle years of the century. Vasily Surikov (1848–1916) was a superlative exponent of the historical category, painting several famous masterpieces including The Boyarynia Morozova and The

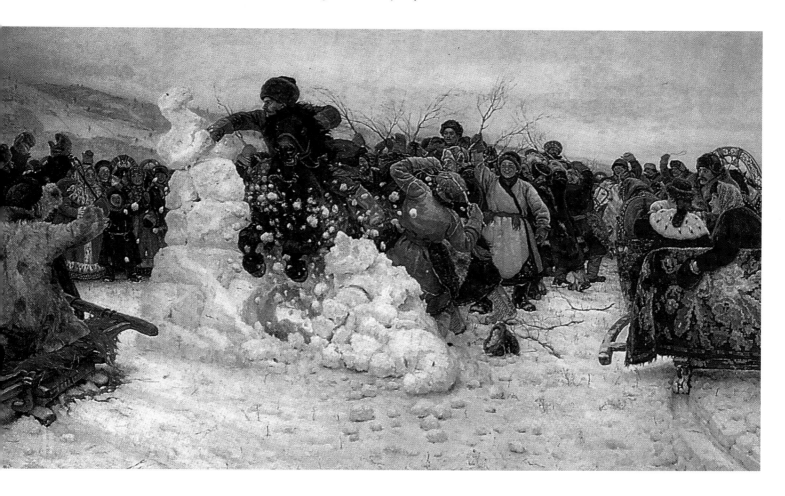

Morning of the Execution of the Streltsy. But he turned his hand equally successfully to what might be termed 'historical-genre' in his exhilarating The Taking of the Snow Fortress [119] (1891). Born in Siberia of a Cossack family, Surikov was immensely proud of his forebears, whom he credited with a splendid mixture of patriotism and independence. As a child he had witnessed an extraordinary custom which was said to be a Cossack tradition commemorating their conquest of Siberia in the 16th and 17th centuries. Every year, on the day before

119-Vasily Surikov

The Taking of the Snow Fortress, 1891
Oil on canvas. 156 x 282 cm
Russian Museum,
St. Petersburg

Lent began, the people of Krasnoyarsk would build a
fortress from blocks of snow and ice, and assemble two
teams. The defenders were installed inside with brooms
and rakes; the attackers, on horseback, attempted to break
in and knock down the crossbeam of the snow gateway.
Surikov and his brother were able to find people who still
knew how to build the fortress, and a reconstruction of

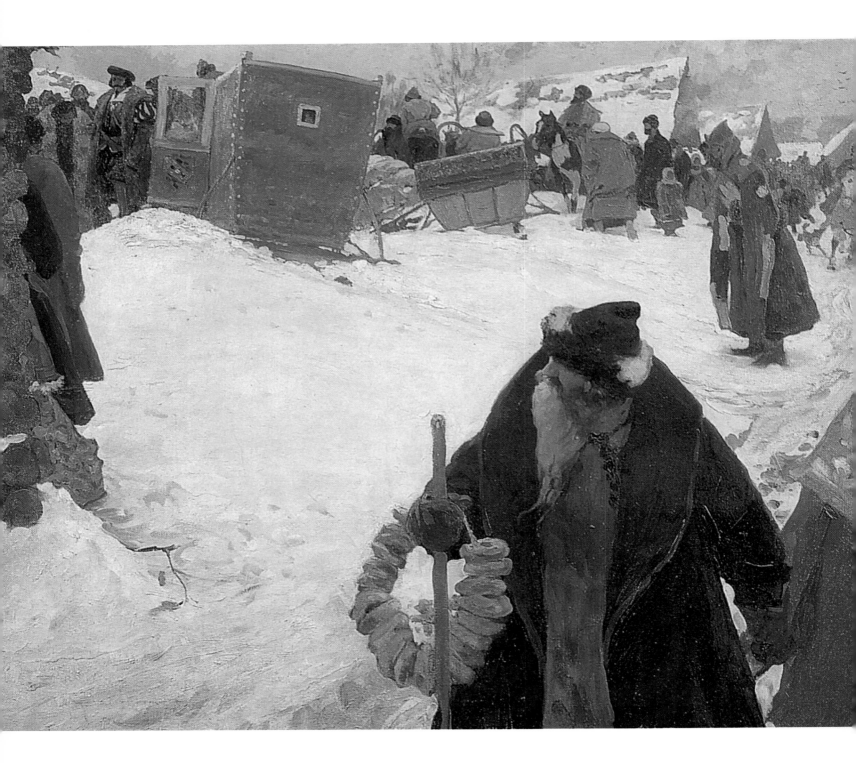

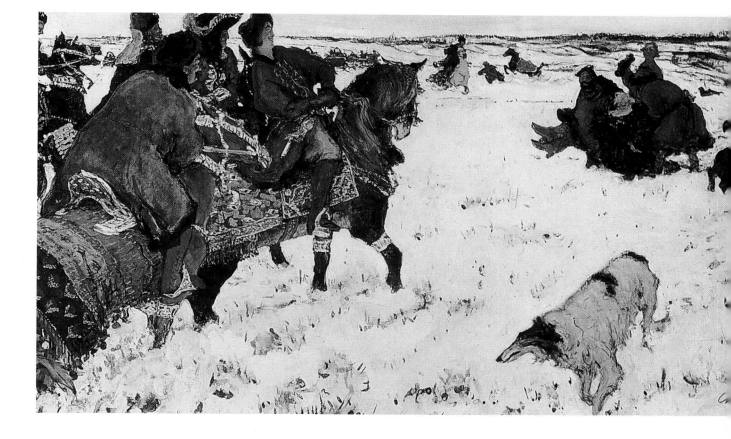

the event drew a tremendous crowd. Surikov's joyous rendering captures the terrific energy of the participants and the excited enthusiasm of the spectators, glowing with youth and health, their brightly coloured clothes adding to the gaiety of the scene: an epic display of the Russian spirit at its most vital and playful.

Sergei Ivanov (1864–1910) also specialized in the 'historical-genre' painting. He shows a less attractive aspect of the Russian character, xenophobia combined with unthinking superstition, in Arrival of Foreigners in the 17th Century [39]. The composition is curiously lop-sided, with a vast blank area in the centre; the main figures are cut in half by the picture's edge, a device emphasizing the urgency with which the old man hurries his daughter away from evil foreign influences. The foreigners seem somewhat dismayed by their hostile reception and the unforgiving climate.

Valentin Serov's first forays into the realm of historical painting were illustrations for a book, Nikolai Kutepov's

'Royal Hunting in Russia'. They exemplify admirably the World of Art principles of a decorative flatness and close attention to the rhythm of the lines and the balance of the composition. Peter the Great Riding to Hounds [112] is a skilful evocation of the style and spirit of the 18th century, revealing the artist's strong sense of history as

22- Vasily Perov

"The Troika" : Young Apprentices Pulling a Water Barrel, 1866

176

well as his grasp of movement and his clever use of colour.

True genre pictures gain immeasurably from being set in the chill and bleakness of winter conditions. Vasily Perov is one of the first painters to utilize this inhospitable climate; in 'The Troika': Young Apprentices Pulling a Water Barrel [22] of 1866 he makes clear how

23- Vasily Perov

The Last Farewell, 1865

35- Victor Vasnetsov

Moving House, 1876
Oil on canvas.
58.3 x 67.2 cm
Tretyakov Gallery, Moscow

much the weather has added to the tribulations of the children hauling their huge burden. Their pinched, hopeless faces express only the desire to get home and warm themselves by a fire. A commentator described how the motifs of snow, ice and fog became 'the bearers of

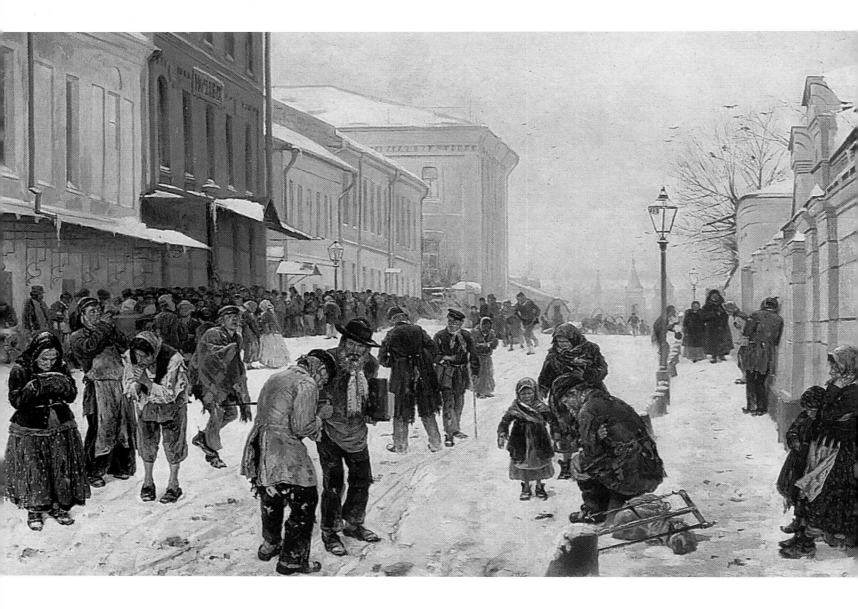

29- Vladimir Makovsky

A Doss-House, 1889
Oil on canvas. 94 x 143 cm
Russian Museum,
St. Petersburg

tragic feeling', and this can be applied equally to The Last Farewell [23]. Here the bowed head of the widow, barely able to urge on her weary horse, and the sad, staring eyes of the bereaved children are expressive of a sorrow that needs no further emphasis.

Another tragic subject is dealt with in Moving House [35]

by the Itinerant Victor Vasnetsov (1848–1926). Vasnetsov believed that every work of art expresses the character of a people, embracing past, present and perhaps future. He certainly captured a very Russian feeling in his scene of two old people forced from their home, stumbling through

the snow with their scrawny, elderly dog.

This gloomy side of the Russian soul is, not surprisingly, more often to the fore in winter. Not the sun coming up, not even the prospect of the doors opening and a bright fire inside seems to cheer the little crowd waiting outside in the chill in Morning at a Tavern [21]. In

84- Stanislav Jukovski

Guests Departing in Dusky Sunlight, 1902
Oil on canvas. 87 x 143.5 cm
Museum of Art, Odessa

104- Valentin Serov

Winter in Abramtsevo. The Church, Study, 1886
Oil on canvas. 20 x 15.5 cm
Tretyakov Gallery, Moscow

Vladimir Makovsky's A Doss-House [29] a more positive spirit reasserts itself as he records a rich variety of characters going about their daily business.

Bonhomie, merry-making and the company of friends are essential nourishment for the Russian soul. A convivial occasion has obviously just come to an end in Stanislav Zhukovsky's Guests Departing in Dusky Sunlight [84]. 'The

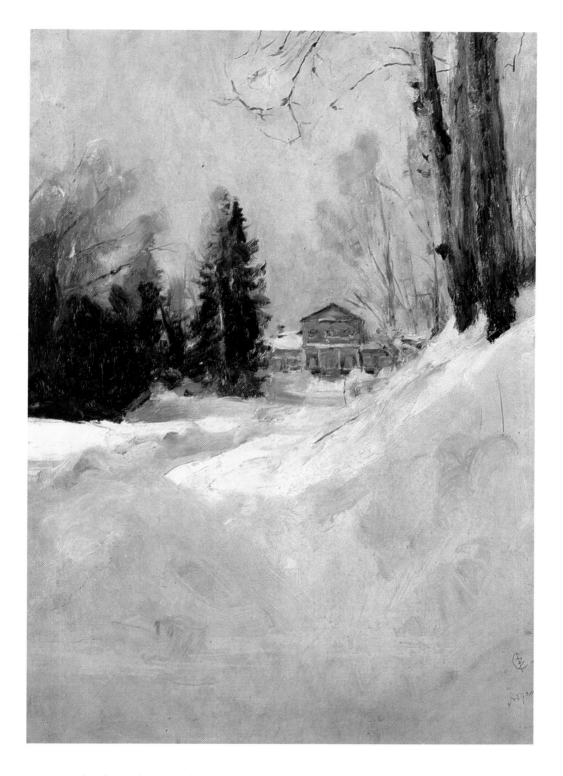

park closed round you as quiet as a countryside; crows scattered the hoar-frost as they settled on the heavy branches of the firs; their cawing echoed like crackling wood; dogs came running across the road from the new kennels in the clearing where the lights shone in the gathering dusk' (Pasternak, 'Doctor Zhivago').

Valentin Serov is rightly considered the first master of

106- Valentin Serov

*Winter in Abramtsevo -
A House, 1886
Oil on panel. 37 x 29 cm
P. N. Krylov collection,
Moscow*

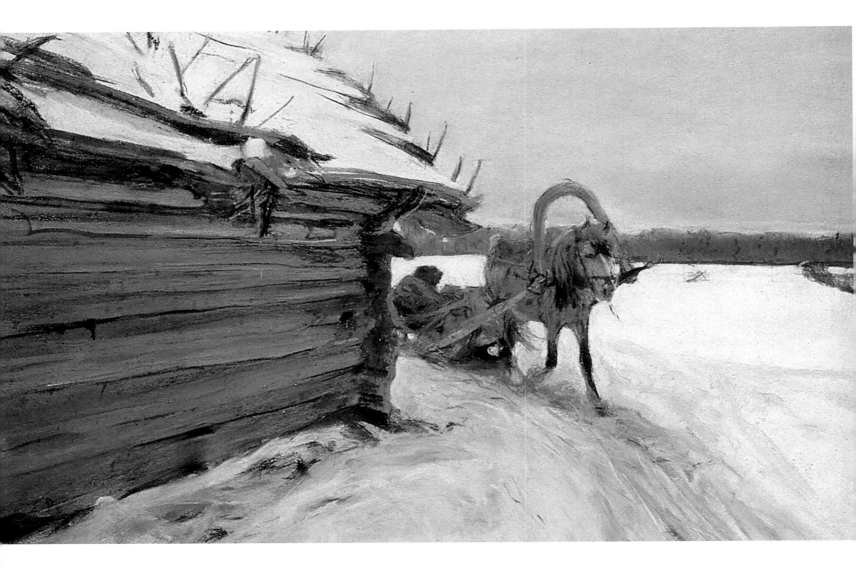

Russian painting. It was to him that the task fell of bringing about the transition to a new aesthetic at the beginning of the 20th century, a new symbolism that would enable the new generation to reflect a changed

world. He was born in St Petersburg in 1865 and studied there at the Academy and in Moscow with Repin. He exhibited with the Itinerants from 1890, and was an active participant in the circle of artists based at the patron and industrialist Xavva Mamontov's estate at

109- Valentin Serov

In Winter, 1898
Gouache and pastel on
cardboard. 51 x 68 cm
Russian Museum,
St. Petersburg

188- Valentin Serov

Rinsing Clothes, Study, 1901
Oil on carboard.
47.5 x 66 cm
Present whereabouts
unknown

Abramtsevo, near Moscow. Two of his oil studies of winter in the little village are of the church [104] and a house [106]. Both are done in an Impressionist improvisatory manner; the church picture, in spite of the thick snow, conveys a feeling of warmth, perhaps inviting us to the comfort of the religious experience; the picture of the house has a shimmering, illusionistic quality.

In the late 1890s Serov became a member of the

103- Valentin Serov

Colts at a Watering-Place. Domotkanovo, 1904
Pastel on paper mounted on cardboard. 40 x 63.8 cm
Tretyakov Gallery, Moscow

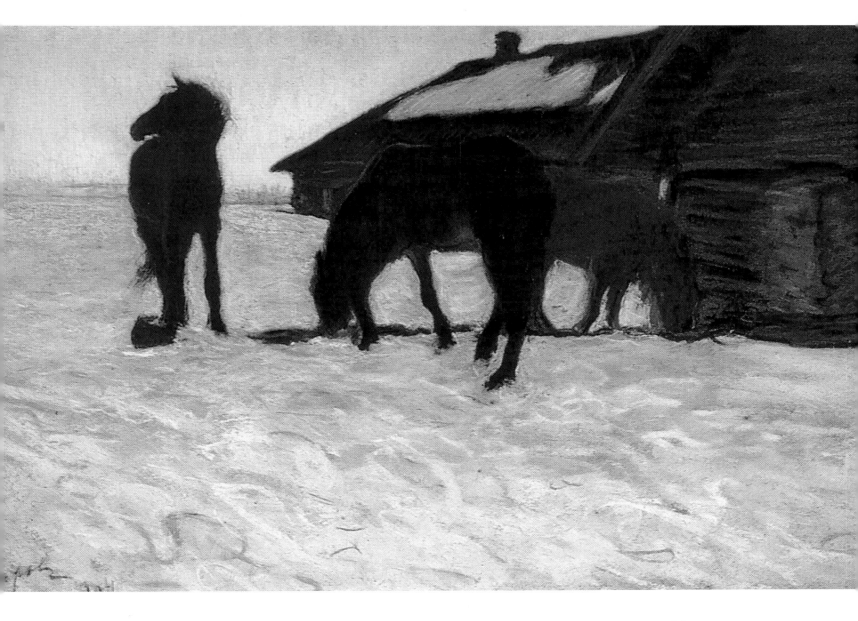

World of Art group. Unintentionally he found himself in something of a position as a leader because of the new methods he evolved, which were taken up by others of his

Following two pages:
115- Boris Koustodiev

Carnival, 1916
Oil on canvas. 61 x 123 cm
Tretyakov Gallery, Moscow

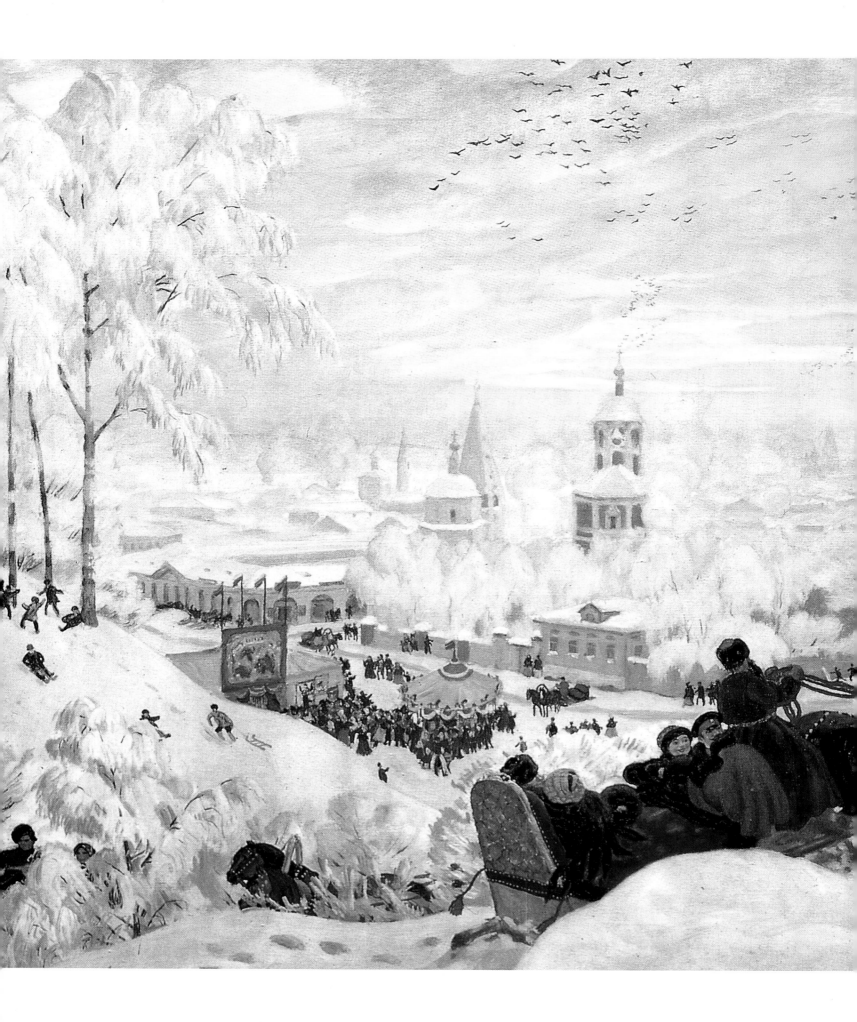

45- Sergei Svetoslavsky

View from the Window of the
Moscow College of Painting,
1878
Oil on canvas. 53 x 74 cm
Tretyakov Gallery, Moscow

93-Vasily Surikov

Boulevard Zubov in Winter
Oil on canvas. 42 x 30 cm
Tretyakov Gallery, Moscow

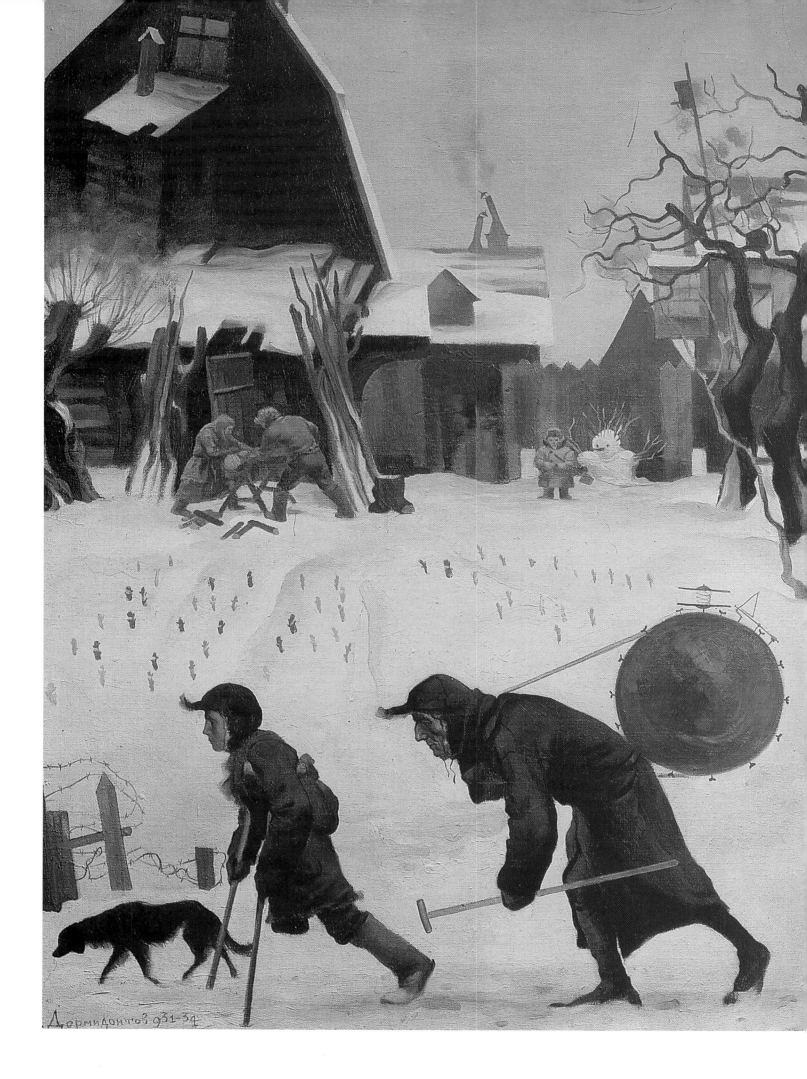

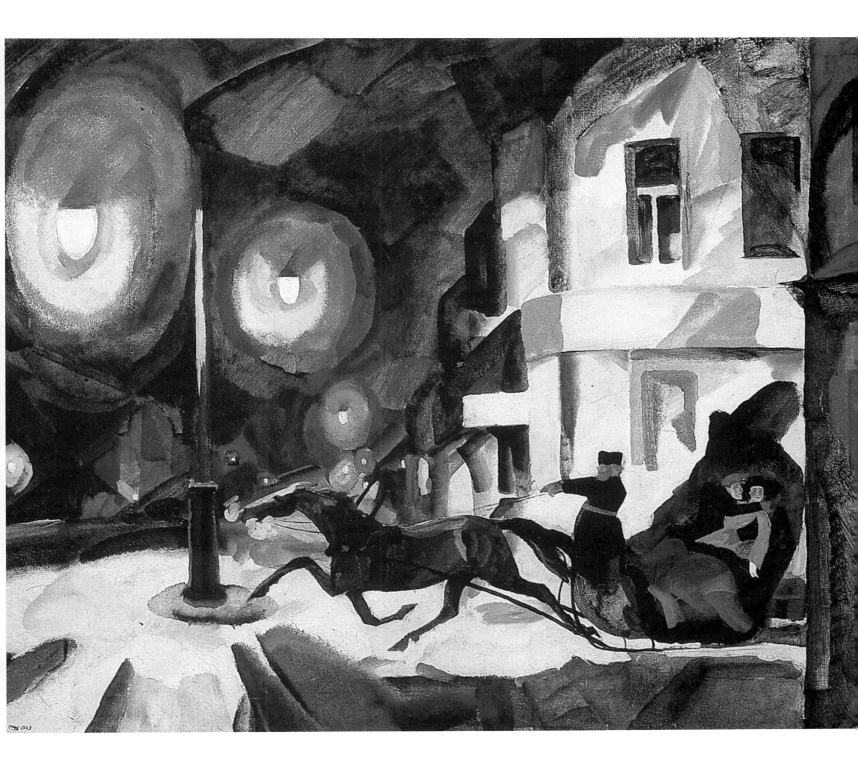

126- Nikolai Dormidontov

Musicians, 1931-1934
Oil on canvas. 76 x 60 cm

Preceeding two pages:
113- Mikhaïl Larionov

Landscape under Snow, 1899
Oil on cardboard. 39 x 57 cm
From the former A. K.
Tomilinalarionova collection,
Paris

generation. His ability to discern the poetic in the midst of the commonplace, his free, painterly manner, his blend of the traditional with the new, all contributed to his ever-increasing and deserved reputation. These qualities are

apparent in three works depicting peasant life. In Winter [109], a gouache of 1898, has a brisk liveliness as the willing little horse trots into view pulling the sleigh with its human cargo. The dirty snow, the promise of more snow in the leaden sky are as realistic as anyone could wish for but also bring out 'the poetry in the ordinary'. Rinsing Clothes [188] shows another unkempt but sturdy little beast calmly chewing his ration of hay as the women carry out a chilly and uncomfortable chore against a similarly threatening sky. The most poetic of the group is Colts at a Watering-Place, Domotkanovo [103], a pastel of 1904 of a delicate, refined technique and unsurpassed poetic sensitivity. The sunset colours in the sky heighten the cold blue-whiteness of the snow, against which the silhouettes of the animals stand out with poignant simplicity. The alert colt at left seems to sense the approach of spring, which is clearly not far away judging by the melting snow on the roof. This is the natural world depicted with the deepest empathy.

Towns and cities often look their best under snow. What heart would not lift at Boris Kustodiev's splendid scene of winter recreation [115] on the outskirts of a town? Everyone is enjoying himself, the throngs of people in the square, the sledgers, even the horses look happy. Surikov's Zubovsky Boulevard in Winter [93] is more contemplative, but not really melancholy – the painter felt at home in Moscow; it reminded him of Krasnoyarsk, particularly in winter. Sergei Svetoslavsky (1857–1931)

114- Mikhaïl Larionov

Trees against the Background of a House, ca. 1900
Pastel and gouache on paper.
32.8 x 51 cm
Russian Museum,
St. Petersburg

provides a very cheerful view of Moscow, too. View from the Window of the Moscow College of Painting [45] is in the best tradition of winter townscape: crisp, clean colours, perfectly clear sky and the extraordinary shapes of the towers and crosses to arrest the eye.

99- Marc Chagall

Over Vitebsk, 1914
Oil on paper. 73 x 92.5 cm
Collection Ayala and Sam
Zacks, Toronto

On the face of it a gloom-laden genre piece, Musicians [126], painted in the early 1930s, has notes of hope offsetting the pitiful state of the two main figures. Nikolai Dormidontov (1898–1962) gives them a characterful determination, a refusal to be depressed by

98- Marc Chagall

Jew in Green, 1914
Oil on paper. 73 x 92.5 cm
Collection Ayala and Sam
Zacks, Toronto

their lack of success. There is suffering, though, in their downcast eyes. Even the dog looks beaten.

Rudolf Frenz (1888–1956) has done a marvellous view of Nevsky Prospekt at Night: Carriage Driver [125] which catches the exhilaration of a drive through the dark city in the snow: 'The unnaturally loud whining of the sleigh on the frozen road aroused an unnaturally long echo from the ice-bound trees of the squares and streets. The lights shining through the frosted windows turned the houses into precious caskets of smoky topaz' (Pasternak, 'Doctor Zhivago').

We finish our winter sleigh-ride with the works of two very great painters. Early works by Mikhail Larionov,

129- Konstantin Pankov

The Hunt, 1930s
Watercolor and gouache on
paper. 62.5 x 87.5 cm

before even his Impressionist phase, reveal a keen interest in the ordinary motifs of city and town. Both Snowy Landscape [113] and Trees Against the Background of a House [114] were done before he was twenty. Marc Chagall's

poetic fantasy Over Vitebsk [99] is a recollection of the world of the child, in which it is perfectly possible for a human to float over the streets. Thus is one very Russian love – of fairy-tale and fantasy – subsumed into another – childhood and nostalgia. The old man in Jew in Green [98] is not, of course, definable in terms of a portrait – rather,

in his earth colours he embodies the spirit of the Russian
landscape, infinitely old, infinitely weary, yet with a
rugged beauty and strength that still retains the capacity
for renewal, for hope – just as, at the end of winter, the
spring breaks through again [129, 94, 187]

187- Mikhaïl Larionov

*Two Girls on a bank of a
Stream, 1920s
Oil on canvas.
92 x 129.5 cm
From the former collection o
A. K. Tomilina-Larionova, Paris*